Cool Restaurants Munich

teNeues

Imprint

Editor:	Joachim Fischer
Editorial coordination:	Sabina Marreiros
Photos (location):	Markus Bachmann (Emporio Armani Caffè, Ederer food), Bacardi (Schumann's Bar am Hofgarten drink), Courtesy Boesel Benkert Hohberg Architekten (Schumann's Bar am Hofgarten), Courtesy Brasserie Leon (Brasserie Leon), Courtesy Lenbach (Lenbach) Courtesy Yum thai kitchen & bar (YUM thai kitchen & bar), Derek Henthorn (Nektar), Quirin Leppert (Lounge$_2$), Stefan Müller-Naumann (Nero Pizza & Lounge), Dirk Wilhelmy (8 Seasons, Blauer Bock Restaurant Bar, Brenner Grill Pasta Bar, Cocoon, Ederer, Essneun Restaurant + Bar, Falk's Bar, Glockenspiel Cafe Restaurant Bar, Hippocampus, Landersdorfer & Innerhofer, Monkey Room, Nage & Sauge, Pur Pur oriental bar & restaurant, Schwarz & Weiz, Soops, Sushi + Soul, Restaurant Tantris)
Introduction:	Joachim Fischer
Layout:	Thomas Hausberg
Imaging & Pre-press:	Jan Hausberg
Map:	go4media. – Verlagsbüro, Stuttgart
Translations:	SAW Communications, Dr. Sabine A. Werner, Mainz Dr. Suzanne Kirkbright (English), Dominique Le Pluart (French) Gemma Correa-Buján (Spanish), Elena Nobilini (Italian) Nina Hausberg (English / recipes)

Produced by fusion publishing GmbH Stuttgart / Los Angeles
www.fusion-publishing.com

Published by teNeues Publishing Group

teNeues Publishing Company
16 West 22nd Street, New York, NY 10010, USA
Tel.: 001-212-627-9090, Fax: 001-212-627-9511

teNeues Book Division
Kaistraße 18, 40221 Düsseldorf, Germany
Tel.: 0049-(0)211-994597-0, Fax: 0049-(0)211-994597-40

teNeues Publishing UK Ltd.
P.O. Box 402, West Byfleet, KT14 7ZF, Great Britain
Tel.: 0044-1932-403509, Fax: 0044-1932-403514

teNeues France S.A.R.L.
4, rue de Valence, 75005 Paris, France
Tel.: 0033-1-55766205, Fax: 0033-1-55766419

www.teneues.com

ISBN:	3-8327-9019-5

© 2005 teNeues Verlag GmbH + Co. KG, Kempen

Printed in Germany

Bibliographic information published by Die Deutsche Bibliothek. Die Deutsche Bibliothek lists this publication in the Deutsche Nationalbibliografie; detailed bibliographic data is available in the Internet at http://dnb.ddb.de.

Contents Page

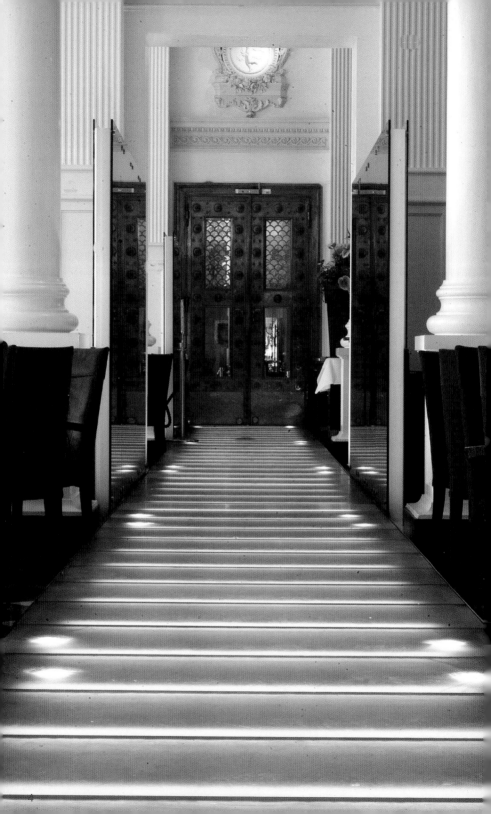

Einleitung

München legt großen Wert darauf, als prunkvoll gestylte Metropole und gleichzeitig als beschauliche, fast ländliche Idylle wahrgenommen zu werden. In dieser Stadt ist man traditionsbewusst und versessen auf Gemütlichkeit, aber auch zeitgeistverliebt und geschäftstüchtig. Die Verbindung dieser Gegensätze erstreckt sich auf alle Bereiche öffentlichen und privaten Lebens, auf Architektur und Design, auf die Läden der großen Einkaufs- und kleinen Nebenstraßen, auf die Kultur und die gastronomische Szene. So wartet der legendäre Viktualienmarkt mit einem prallen Angebot auf: vom frischen Gemüse der Region über fernöstliche Gewürze bis hin zu leckeren Antipasti. Von dieser Angebotsvielfalt profitieren auch die unzähligen Restaurants der Stadt, die mit Sternen dekorierten Hochburgen exquisiter Genüsse ebenso wie das hippe Szenelokal. Qualität steht hoch im Kurs. Das gilt selbstverständlich für das, was auf den Teller kommt, aber auch für die Architektur und das Design der Restaurants. Meister der gastronomischen Zunft sorgen für eine erstklassige Küche, aber man genießt auch Interieur und Ambiente. So spiegelt sich der Facettenreichtum der Stadt auch in ihren Restaurants und Bars wider. Die Gestaltung des Lenbach wurde vom Stararchitekten Terence Conran unter das Motto der sieben Sünden Neid, Gier, Lust, Trägheit, Zorn, Eitelkeit und Völlerei gestellt. Im Interieur des Emporio Armani Caffè dagegen findet sich ganz der Stil des Modeschöpfers wieder: reduziertes Design, das sachlich ist, ohne kalt zu wirken, und überall auf der Welt verstanden wird. Der Blaue Bock setzt auf traditionelle Rezepte, modern interpretiert und im Brenner Grill ist Purismus der Leitgedanke. Hohe Promidichte und die besten Cocktails zeichnen immer noch Schumann's Bar aus – inzwischen schon eine Legende unter den Bars. Nichts ist in München banal – selbst die einzelne Salatsauce im Tantris besteht aus 30 Zutaten. Für *Cool Restaurants Munich* wurden aus der reichhaltigen gastronomischen Szene Münchens ausgewählte Restaurants und Bars zusammengestellt.

Joachim Fischer

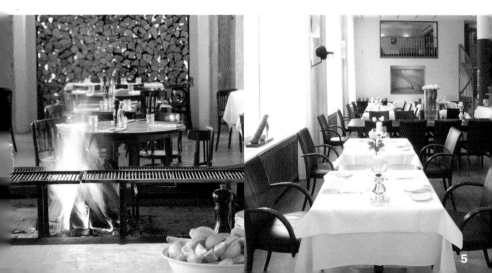

Introduction

Munich highly values cultivating an image as a magnificent, styled metropolis and, at the same time, a tranquil, almost rural idyll. In this city, where they are tradition-conscious and crazy about comfort, they are also in love with the *Zeitgeist* and have a flair for commerce. The marriage of these opposites extends to all areas of public and private life, to architecture and design, to shops on major shopping boulevards and small backstreets, to culture and the restaurant scene. That's how the legendary Viktualienmarkt (food market) has a plentiful supply of products on offer: from fresh, regional vegetables to far eastern spices and the tasty antipasti. The city's scores of restaurants also profit from the variety on offer, whether it's star-rated strongholds of exquisite delicacies or the hip and popular bar. Quality is at a premium. Of course, that counts for the food on the plate as well as for the restaurants' architecture and design. Masters of the gastronomic trade attend to the first-rate cuisine, but guests also enjoy the interior and ambiance. This is how the city's richness in all kinds of facets is reflected in its restaurants and bars. Star architect, Terence Conran, designed the Lenbach under the motto of the seven cardinal sins—envy, greed, lust, laziness, anger, vanity and gluttony. By contrast, the interior of the Emporio Armani Caffè perfectly echoes the fashion designer's style: reduced design, which is objective, yet without looking cold and appreciated all over the world. The Blauer Bock relies on traditional recipes, with modern interpretations; and purism is the guiding idea in the Brenner Grill. Schumann's Bar is well known as a magnet for the rich and famous and the best cocktails—by now, it has already achieved legendary status among the bars. In Munich, nothing is trivial—even one single salad dressing at Trantris is made of 30 ingredients. For *Cool Restaurants Munich*, selected restaurants and bars were chosen to feature from Munich's wide-ranging restaurant scene.

Joachim Fischer

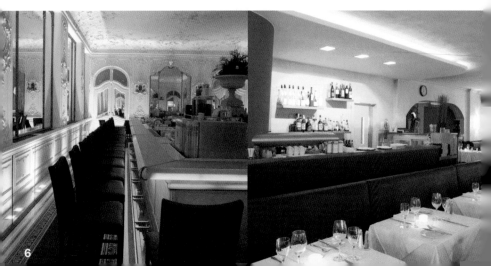

Introduction

Munich attache une grande importance à son image de métropole luxueuse et paisible, voire idyllique. Les Munichois revendiquent leurs traditions et défendent farouchement leur tranquillité, mais cela ne les empêche pas d'être férus de modernité et d'avoir le sens des affaires. La réunion de ces contrastes s'exprime dans tous les domaines de la vie publique et privée. Elle se manifeste dans l'architecture et le design, dans les magasins des grandes avenues comme des petites rues transversales, dans la vie culturelle et gastronomique. Le célèbre Viktualienmarkt (marché aux victuailles) offre la même diversité contrastée : cela va des légumes frais du terroir aux épices d'Orient, sans oublier les délicieux antipasti. Cette profusion fait le bonheur des innombrables restaurants de la ville, qu'il s'agisse des hauts lieux étoilés pour les plaisirs gourmands ou des établissements à la mode. La qualité prime avant tout ! Qualité de table, bien sûr, mais pas seulement. Architecture et design doivent répondre à la même exigence. Les grandes toques veillent à l'excellence culinaire dans un cadre et une ambiance à l'unisson. Les multiples facettes de la ville se reflètent dans les restaurants et les bars. Le décor du « Lenbach » a été conçu par le prestigieux architecte Terence Conran qui a mis en scène les sept péchés capitaux : la jalousie, l'envie, la luxure, la paresse, la colère, la vanité et la gloutonnerie. Au « Emporio Armani Caffè », par contre, on retrouve tout le style du grand couturier : design simple et sobre sans être froid, tel qu'on l'aime dans le monde entier. Le « Blauer Bock » s'est spécialisé dans les recettes traditionnelles adaptées au goût contemporain, et au « Brenner Grill », c'est le purisme qui donne le ton. Le « Schumann's Bar » attire beaucoup de VIP, et ses cocktails restent imbattables – un bar dont la réputation n'est plus à faire ! Rien n'cst banal à Munich, pas même une simple vinaigrette qui, comme chez « Tantris », peut compter jusqu'à une trentaine d'ingrédients. Dans ce milieu gastronomique foisonnant, les meilleures adresses ont été sélectionnées pour le guide *Cool Restaurants Munich*.

<div align="right">

Joachim Fischer

</div>

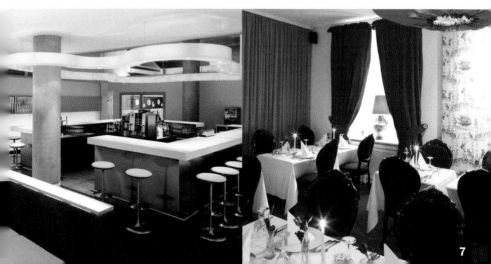

Introducción

Munich da mucha importancia a ser percibida como una metrópoli diseñada de forma suntuosa y, al mismo tiempo, como un idilio apacible, casi rural. En esta ciudad se es consciente de la tradición y se está empeñado en la comodidad, pero también se ama el espíritu de la época y se es hábil para los negocios. La unión de estos contrarios se extiende a todos los ámbitos de la vida pública y privada, a la arquitectura y el diseño, a las tiendas de las grandes calles de comercios y las pequeñas calles laterales, a la cultura y a la escena gastronómica. Así, el legendario Viktualienmarkt (mercado de alimentos) espera con una oferta repleta: desde la verdura fresca de la región pasando por las especias del lejano Oriente hasta los ricos antipasti. De esta oferta variada se aprovechan también los innumerables restaurantes de la ciudad, los baluartes de unos placeres exquisitos decorados con estrellas igual que el local de moda de la escena. La calidad goza de prestigio. Esto vale naturalmente para lo que llega al plato, pero también para la arquitectura y el diseño de los restaurantes. Los maestros del gremio gastronómico se preocupan por una cocina de primera clase, pero se disfruta también del interior y el ambiente. Así, la riqueza de facetas de la ciudad también se refleja en sus restaurantes y bares. El diseño del Lenbach fue puesto por el arquitecto estrella Terence Conran bajo el lema de los siete pecados capitales: la envidia, la avaricia, la lujuria, la pereza, la ira, la soberbia y la gula. En el interior del Emporio Armani Caffè, en cambio, se halla totalmente el estilo del creador de moda: el diseño reducido, que es racional sin parecer frío, y es comprendido en todas las partes del mundo. El Blauer Bock apuesta por las recetas tradicionales interpretadas de forma moderna y en el Brenner Grill el purismo es la idea central. Gran cantidad de celebridades y los mejores cócteles caracterizan todavía el Schumann's Bar – entretanto ya una leyenda entre los bares; nada es banal en Munich – incluso la salsa para ensalada en el Tantris consta sola de 30 ingredientes. Para *Cool Restaurants Munich* se recopilaron restaurantes y bares seleccionados de la amplia escena gastronómica de Munich.

Joachim Fischer

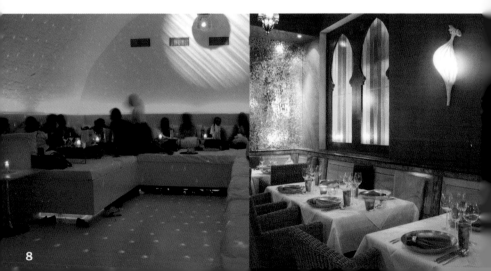

Introduzione

Monaco ci tiene molto ad essere considerata una metropoli dallo stile sfarzoso e al contempo un quieto luogo idilliaco, quasi campestre. La gente di Monaco è consapevole delle proprie tradizioni e va pazza per la comodità, ma è anche innamorata dello spirito del tempo ed è abile negli affari. La sintesi di queste contraddizioni si estende a tutti i settori della vita pubblica e privata, all'architettura e al design, ai negozi delle grandi vie dello shopping e alle piccole vie secondarie, alla cultura e alla scena gastronomica. E così il leggendario Viktualienmarkt (mercato alimentare) propone una ricca varietà che va dalle verdure fresche locali alle spezie dell'Estremo Oriente fino ad antipasti appetitosi. Anche gli innumerevoli ristoranti della città traggono profitto di questa varietà di offerta, tanto le roccaforti di squisiti piaceri insignite con stelle quanto il locale trendy. La qualità è molto quotata. Ciò vale ovviamente per ciò che viene servito sui piatti ma anche per l'architettura e il design dei ristoranti. I maestri della scena gastronomica offrono una cucina di primissima qualità, gli interni e l'ambiente uno spettacolo per gli occhi. Le tante sfaccettature della città si riflettono quindi anche nei suoi ristoranti e locali. Il Lenbach è stato ideato dall'architetto di grido Terence Conran, ispiratosi ai sette peccati capitali invidia, avarizia, lussuria, accidia, ira, superbia e gola. All'interno dell'Emporio Armani Caffè si ritrova invece il tocco dello stilista: un design semplificato, sobrio, che non risulta però freddo ed è apprezzato in tutto il mondo. Il Blauer Bock punta su ricette tradizionali riproposte in chiave moderna, mentre al Brenner Grill il leitmotiv è il purismo. La grande presenza di vip e i cocktail migliori in assoluto distinguono ancora lo Schumann's Bar, ormai una leggenda tra i locali. A Monaco non c'è niente di banale: la sola salsa per insalate del Tantris contiene 30 ingredienti. *Cool Restaurants Munich* è una raccolta selezionata di ristoranti e locali della ricca scena gastronomica di Monaco.

Joachim Fischer

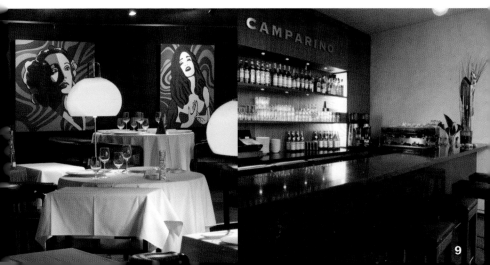

Maximilianstraße 2 | 80539 München | Altstadt
Phone: +49 89 24 29 44 44
www.8-seasons.com | office@8-seasons.de
Subway: Odeonsplatz
Opening hours: Wed–Thu 7 pm to 1 am, Fri–Sat 7 pm to 2 am
Average price: € 12
Special features: Celeb hangout, drinks only, member area

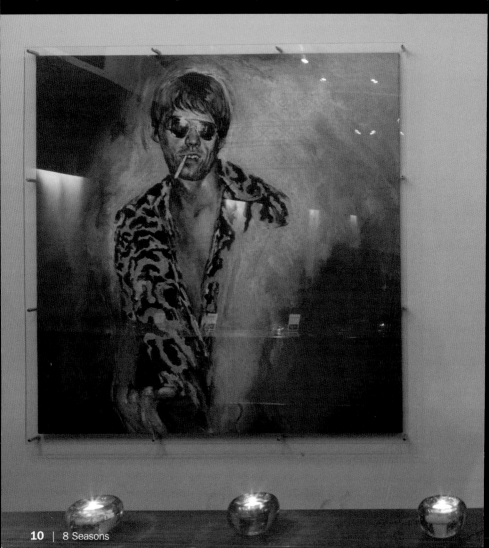

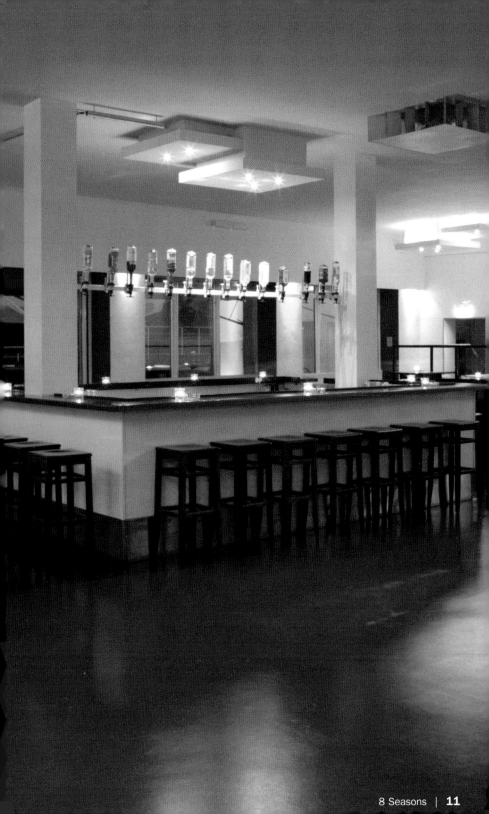

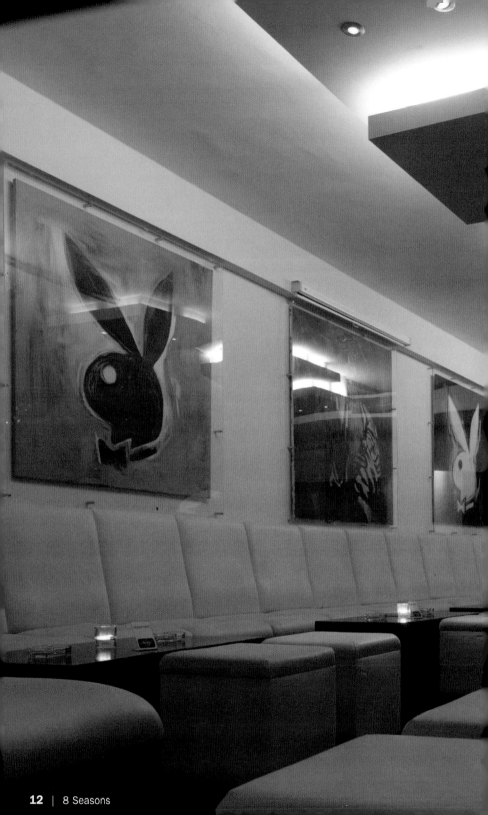

Blauer Bock Restaurant Bar

Design: Boesel Benkert Hohberg Architekten
Chef: Hans Jörg Bachmeier

Am Viktualienmarkt, Sebastiansplatz 9 | 80331 München | Altstadt
Phone: +49 89 45 22 23 33
www.restaurant-blauerbock.de | mail@restaurant-blauerbock.de
Subway: Marienplatz
Opening hours: Mon–Fri lunch 12 noon to 2:30 pm, dinner 6:30 pm to 10:30 pm,
Sun dinner 6:30 pm to 10:30 pm, Sat closed
Average price: € 45
Cuisine: Pur classical European

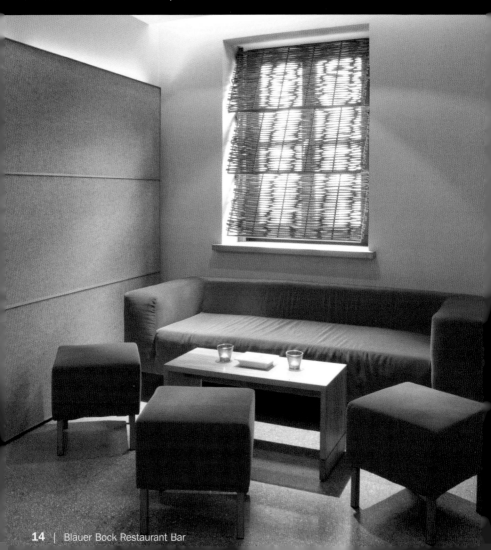

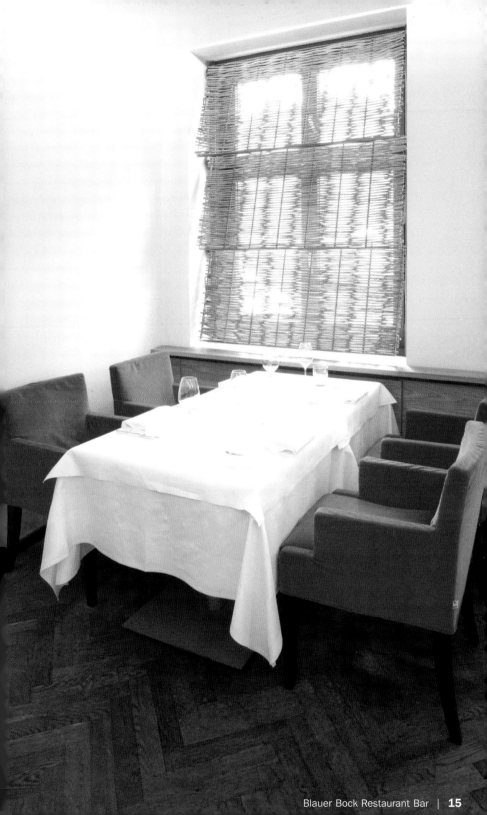

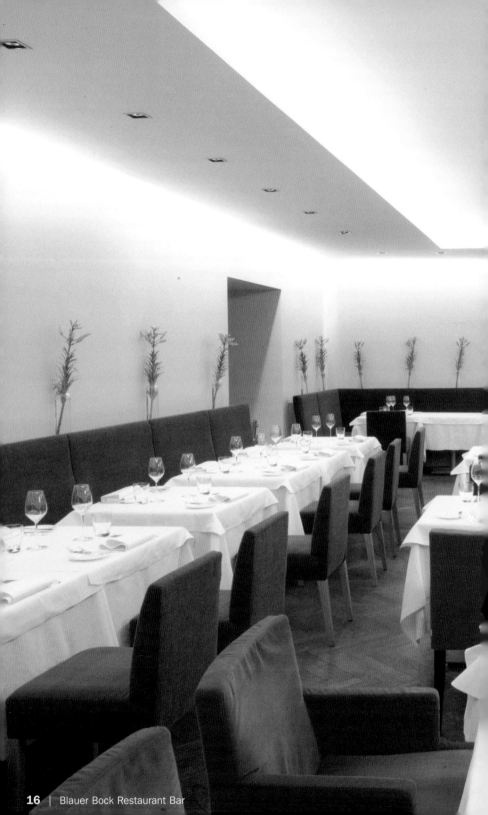

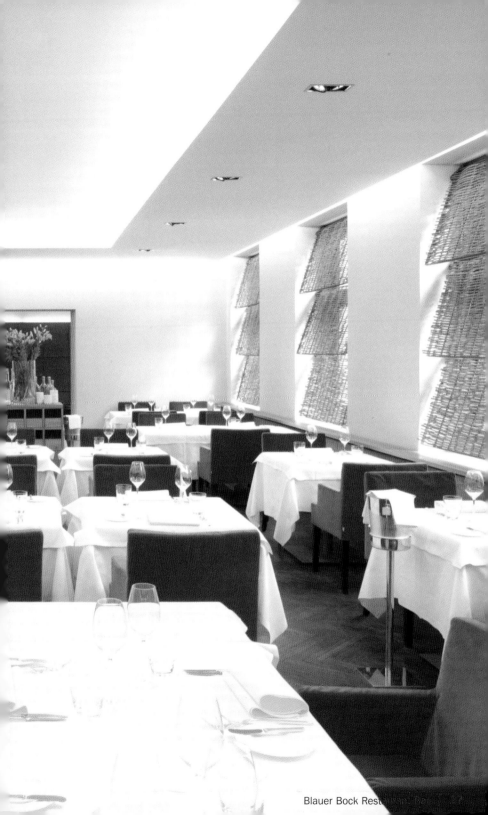

Blauer Bock Restaurant, Ba...

Zander
auf Rotweinspinat

Pike-perch on Red Wine Spinach
Sandre sur épinards au vin rouge
Lucio con espinacas al vino tinto
Lucioperca su spinaci al vino rosso

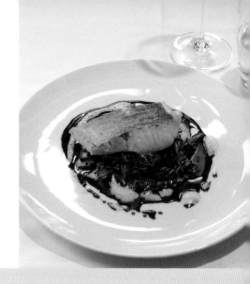

500 ml Rotwein
125 ml roter Portwein
4 Schalotten
150 g Butter
Salz

200 g Spinat
30 g Butter
Salz, Pfeffer aus der Mühle

4 Zanderfilets mit Haut à 150 g
3 EL Olivenöl
Salz, Pfeffer

Rotwein und Portwein zusammen mit den geschnittenen Schalotten in einer kleinen Sauteuse einkochen bis die Flüssigkeit eine geleeartige Konsistenz erreicht hat. Vom Herd nehmen, 5 Minuten abkühlen lassen, wieder auf die Flamme stellen und die Masse mit einem Spritzer Rotwein lösen. Nach und nach die Butter einrühren und salzen. Sollte die Sauce zu sauer sein, mit etwas Portwein süßen.
Spinat waschen und mit der Butter zugedeckt weich dünsten. Mit Salz und Pfeffer abschmecken und warm halten. Zander auf der Haut ca. 5–6 Minuten im Öl braten. Spinat auf den Tellern verteilen, mit der Rotweinsauce überziehen und den Zander darauf anrichten.

500 ml red wine
125 ml red Port
4 shallots
5 oz butter
Salt

7 oz spinach
1 oz butter
Salt, pepper from the mill

4 pike-perch filets with skin, 5 oz each
3 tbsp olive oil
Salt, pepper

Bring red wine, port and chopped shallots in a small pot to a boil and reduce liquid to a jelly like consistency. Remove from the stove, let cool down for 5 minutes, put back on stove and losen the mixture with a splash of red wine. Slowly stir in the butter and salten. If the sauce is too sour, sweeten with Port.
Wash spinach and sauté in butter. Season with salt and pepper and keep warm. Fry pike-perch on skin side in oil for approx. 5–6 minutes. Put spinach on plates, cover with red wine sauce and place pike-perch on top.

500 ml de vin rouge
125 ml de porto rouge
4 échalotes
150 g de beurre
Sel

200 g d'épinards
30 g de beurre
Sel, poivre du moulin

4 filets de sandre avec la peau, à 150 g
3 c. à soupe d'huile d'olive
Sel, poivre

Cuire dans une petite sauteuse le vin, le porto avec les échalotes émincées jusqu'à obtenir la consistance d'une gelée. Retirer du feu, laisser refroidir 5 minutes, remettre sur le feu et détacher la masse avec un trait de vin rouge. Incorporer peu à peu le beurre et saler. Si la sauce est trop aigre, sucrer en rajoutant du porto.
Laver les épinards, les étuver au beurre en gardant couvert. Saler, poivrer et réserver au chaud. Faire revenir le sandre côté peau dans l'huile environ 5 à 6 minutes. Dresser les épinards sur les assiettes, napper de sauce au vin rouge et déposer sur le dessus les filets de sandre.

500 ml de vino tinto
125 ml de vino tinto de Oporto
4 chalotes
150 g de mantequilla
Sal

200 g de espinacas
30 g de mantequilla
Sal, pimienta del molinillo

4 filetes de lucio con piel de 150 g cada uno
3 cucharadas de aceite de oliva
Sal, pimienta

Espesar el vino tinto y el vino de Oporto junto con los chalotes cortados en una pequeña sartén para saltear hasta que el líquido haya alcanzado una consistencia gelatinosa. Sacar del fuego, dejar enfriar 5 minutos, poner de nuevo al fuego y deshacer la masa con un chorrito de vino tinto. Ir mezclando la mantequilla y salar. Si la salsa estuviese demasiado ácida endulzar con un poco de vino de Oporto.
Lavar las espinacas y rehogar tapadas con la mantequilla hasta que estén blandas. Sazonar con sal y pimienta y mantener calientes. Freír en aceite el lucio por la parte de la piel aprox. 5–6 minutos. Distribuir las espinacas en los platos, rociar con la salsa de vino tinto y colocar encima el lucio.

500 ml di vino rosso
125 ml di vino porto rosso
4 scalogni
150 g di burro
Sale

200 g di spinaci
30 g di burro
Sale, pepe appena macinato

4 filetti di lucioperca da 150 g con la pelle
3 cucchiai di olio d'oliva
Sale, pepe

In una piccola sauteuse fate ispessire il vino rosso e il vino porto insieme agli scalogni tagliati finché il liquido assumerà una consistenza gelatinosa. Togliete dal fornello, lasciate raffreddare per 5 minuti, rimettete sulla fiamma e sciogliete la massa con uno spruzzo di vino rosso. Incorporate il burro poco alla volta e salate. Se la salsa è troppo aspra, dolcificate con un po' di vino porto. Lavate gli spinaci e fateli cuocere al vapore con il burro a pentola coperta. Correggete con sale e pepe e tenete in caldo. Friggete il lucioperca con la pelle nell'olio per ca. 5–6 minuti. Distribuite gli spinaci sui piatti, ricoprite con la salsa al vino rosso e sistematevi sopra il lucioperca.

Brasserie Leon

Design: Dörken + Partner Innenarchitektur | Chef: Christian Egger

Bayerstraße 3–5 | 80335 München | Ludwigsvorstadt-Isarvorstadt
Phone: +49 89 54 32 17 87
www.leons.org | info@leons.org
Subway: Hauptbahnhof, Karlsplatz / Stachus
Opening hours: Mon–Sat 10 am to 1 am, Sun 9 am to 1 am
Average price: € 10
Cuisine: Mediterranean contemporary
Special features: Brunch, patio zen-garden

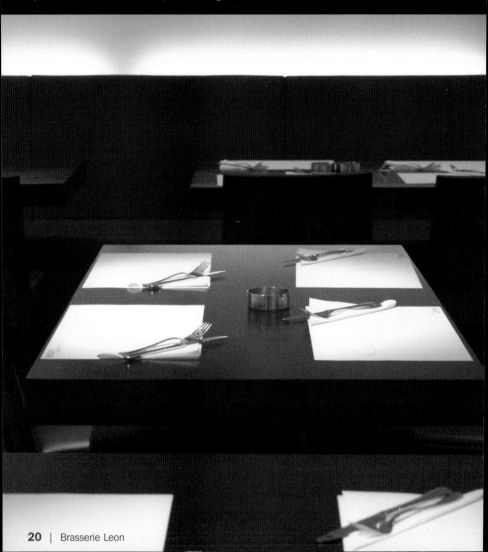

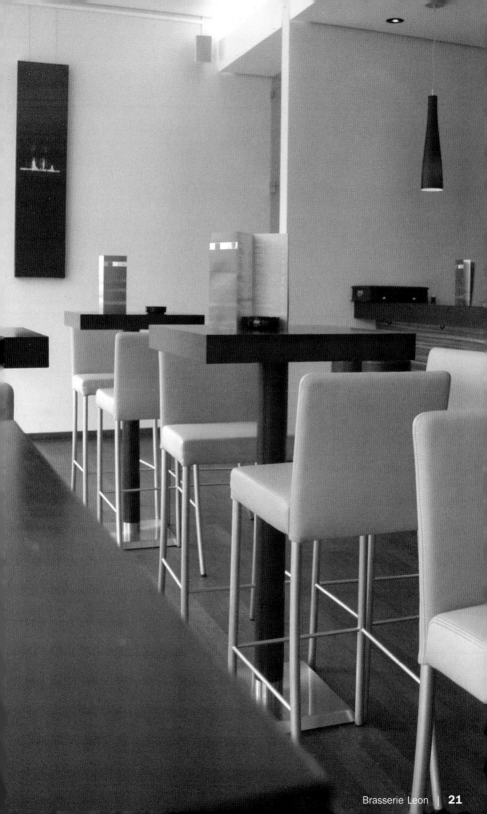

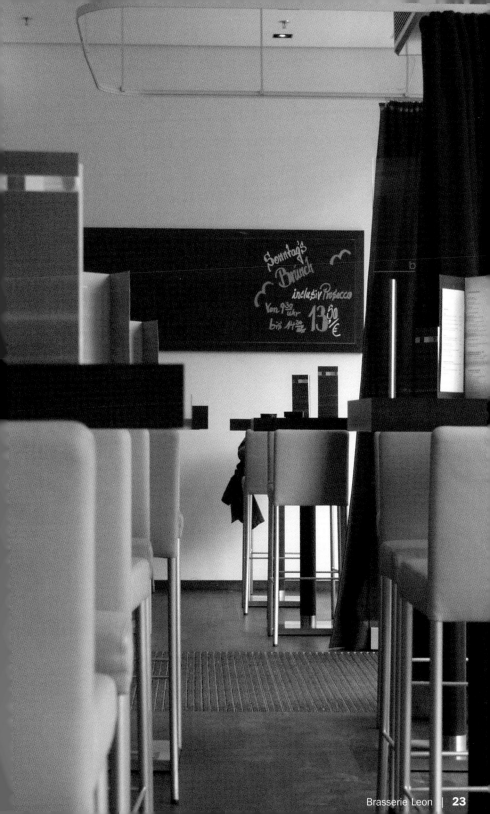

Sonntag's
Brunch
inclusiv Prosecco
Von 9⁰⁰ Uhr
bis 14³⁰ 13,⁵⁰€

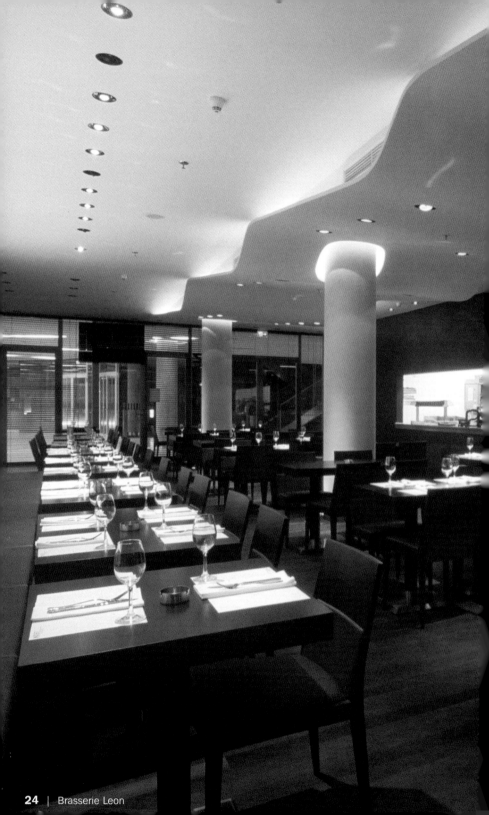

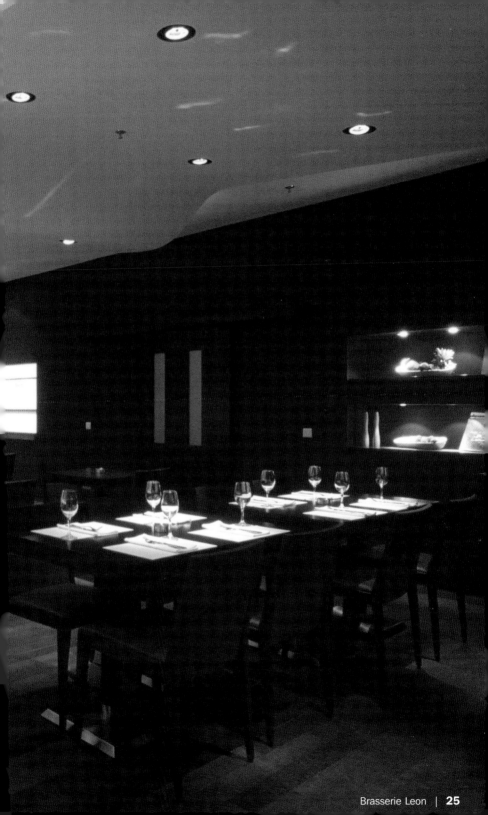

Brenner Grill Pasta Bar

Design: Albert Weinzierl | Chef: Sebastiano Sposito

Maximilianstraße 15 | 80539 München | Altstadt
Phone: +49 89 4 52 28 80
www.brennergrill.de | info@brennergrill.de
Subway: Marienplatz, Odeonsplatz
Opening hours: Every day 8:30 am to 2 am
Average price: € 7–23
Cuisine: Mediterranean
Special features: Open fireplace, celeb hangout, bar scene

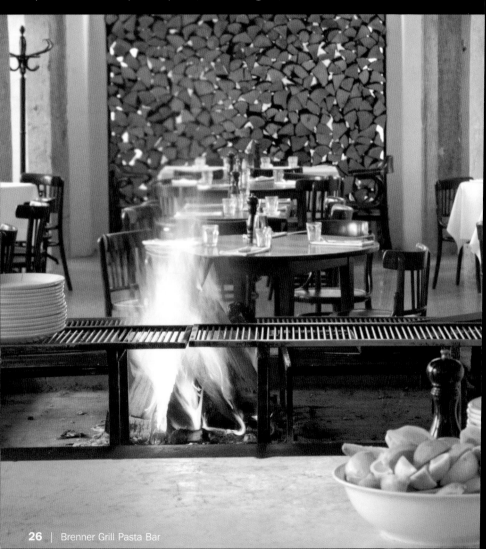

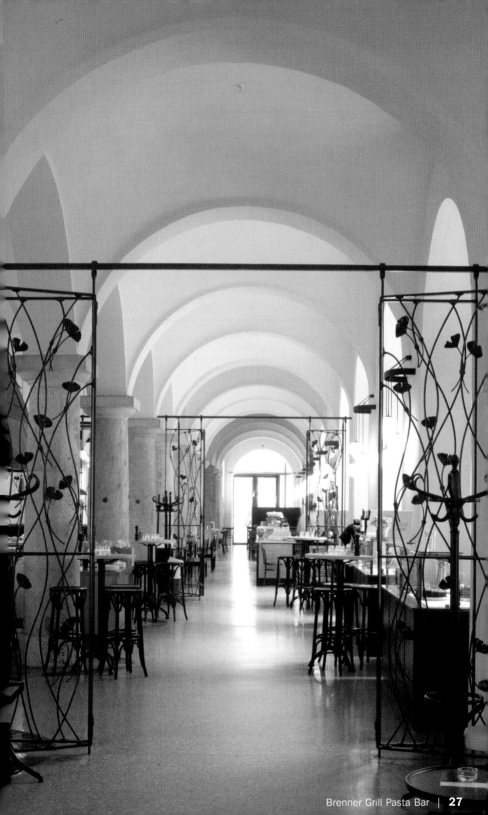

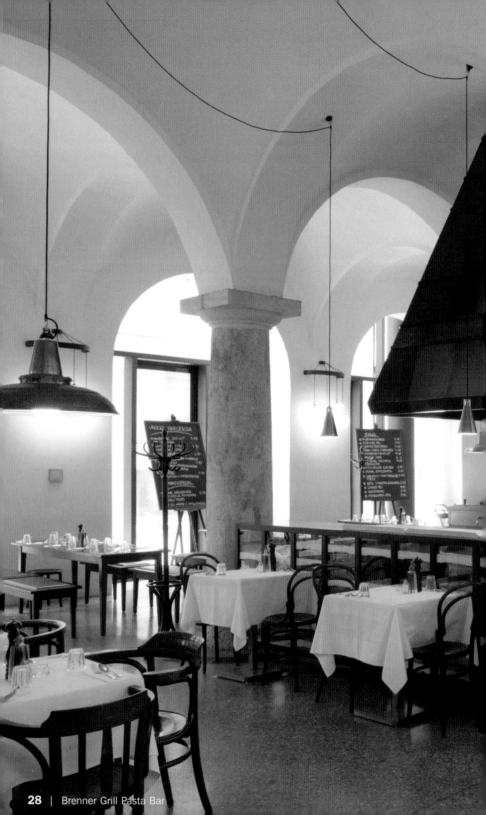

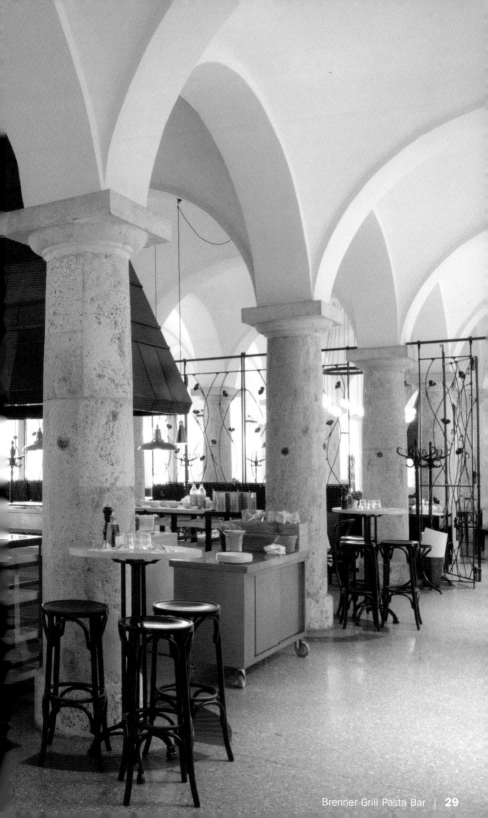

Cocoon

Design: Viscons | Chef: Andreas Schweiger

Christophstraße 3 | 80538 München | Lehel
Phone: +49 89 25 54 19 66
www.go-cocoon.de
Subway: Lehel
Opening hours: Tue–Fri 6 pm to 1 am, Sat 6:30 pm to 1 am
Average price: € 16–20
Cuisine: Young & wild
Special features: Reservation essential, hot spot for creative people, celeb hangout

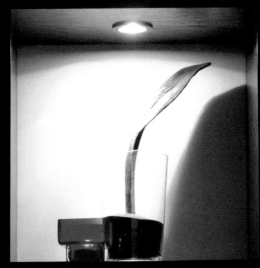

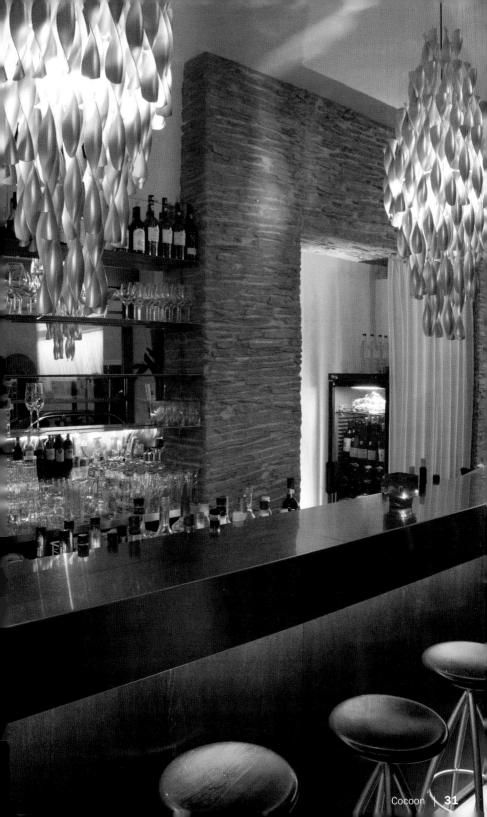

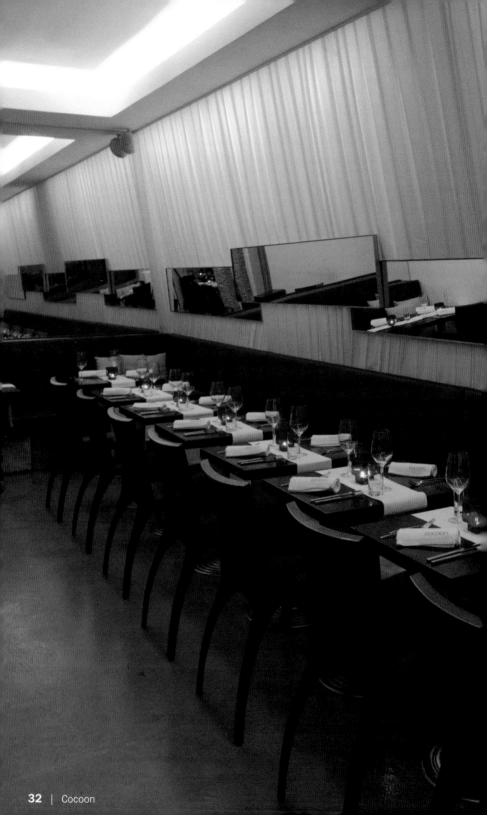

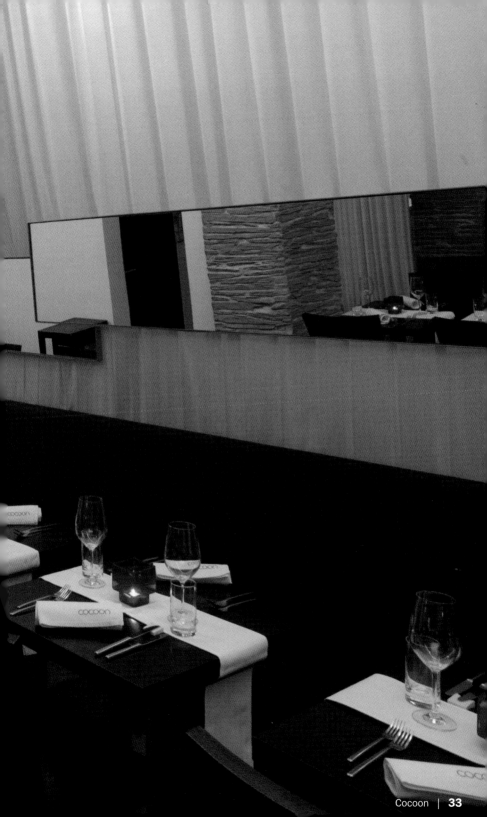

Thunfisch-Variation

Tuna Variation

Variation de thon

Variación de atún

Variazione di tonno

Tartar: 200 g roher Thunfisch (Sushi-Qualität); Salz, Pfeffer; 3 EL geröstetes Sesamöl; 2 EL Sushi-Essig (Reis-Essig); je 2 TL schwarze und weiße Sesamkörner; 2 TL frischer Koriander, gehackt; 8 Wan-Tan-Blätter

Gebraten: 240 g roher Thunfisch (Sushi-Qualität); 1 Prise Salz; 2 TL Tandoori-Gewürz; Sesamöl zum Braten

Zitrussalat: 2 Orangen; 1 Grapefruit; 2 Pomelo; 2 EL helle Fischsauce; 1/2 Stange Zitronengras; etwas geröstetes Sesamöl; Salz, Zucker; Schnittlauch und Tandoori-Pulver zum Garnieren

Für das Tartar den Thunfisch in kleine Würfel schneiden. Mit etwas Salz, Pfeffer, geröstetem Sesamöl und Sushi-Essig abschmecken. Zum Schluss den Koriander und die Sesamkörner hinzugeben. Die Wan-Tan-Blätter diagonal halbieren, so dass zwei Dreiecke entstehen und bei 150 °C in der Fritteuse goldgelb backen.

Thunfisch mit einer Prise Salz würzen und in Tandoori wenden. Öl in einer Pfanne stark erhitzen und den Thunfisch von jeder Seite ca. 5 Sekunden braten. Diagonal in zwei Stücke schneiden.

Zitrusfrüchte filetieren. Den Saft in einer Schüssel auffangen und mit Salz, Zucker und heller Fischsauce abschmecken. Das Zitronengras in feine Ringe schneiden und unter die Filets heben.

Das Tartar auf den Wan-Tan-Blättern anrichten, den gebratenen Thunfisch aneinander legen und den Zitrussalat mit der Vinaigrette anrichten. Mit Schnittlauch und Tandoori garnieren.

Tartar: 7 oz raw tuna (sushi-quality); salt, pepper; 3 tbsp roasted sesame oil; 2 tbsp sushi vinegar (rice-vinegar); 2 tsp black and white sesame seeds; 2 tsp fresh cilantro, chopped; 8 Wan-Tan leaves

Fried: 9 oz raw tuna (sushi-quality); pinch salt; 2 tsp Tandoori-seasoning; sesame oil for frying

Citrus-Salad: 2 oranges; 1 grapefruit; 2 pomelos; 2 tbsp light fish-sauce; 1/2 stalk lemongrass; roasted sesame oil; salt, sugar; chives and Tandoori-seasoning for decoration

For the tartar cut the tuna into small cubes. Season with salt, pepper, sesame oil and sushivinegar. Add sesame seeds and cilantro. Cut the Wan-Tan leaves in half diagonally, to make two pieces and deep-fry in oil until goldenbrown.

Season tuna with salt and roll in Tandoori. Heat oil in a pan until very hot and fry tuna 5 seconds from each side. Cut in half diagonally.

Cut citrus fruits in filets. Pour juice in a bowl and season with salt, sugar and fish-sauce. Cut lemon gras in fine rings and fold under citrus filets.

Place tartar on Wan-Tan leaves, put fried tuna beside each other and garnish citrus-salad with vinaigrette, chives and Tandoori.

Tartare : 200 g de thon cru (de qualité sushi) ; sel, poivre ; 3 c. à soupe d'huile de sésame grillé ; 2 c. à soupe de vinaigre de sushi (vinaigre de riz) ; 4 c. à café de graines de sésame noir et blanc ; 2 c. à café de coriandre hachée ; 8 feuilles de wan-tan

Grillade : 240 g de thon cru (de qualité sushi) ; 1 pincée de sel ; 2 c. à café de tandoori ; huile de sésame pour friture

Salade d'agrumes : 2 oranges; 1 pamplemousse ; 2 pomelos ; 2 c. à soupe de sauce de poisson claire ; 1/2 tige de citronnelle ; un peu d'huile de sésame grillé ; sel, poivre ; ciboulette et poudre de tandoori pour la garniture

Pour le tartare, couper le thon en dés. Assaisonner avec un peu de sel, de poivre, d'huile de sésame grillé et de vinaigre de sushi. Ajouter en dernier la coriandre et les graines de sésame. Couper en diagonale les feuilles de wan-tan pour obtenir deux triangles et les faire dorer à 150 °C dans la friteuse.
Assaisonner le thon avec une pincée de sel et le passer dans le tandoori. Chauffer à feu vif de l'huile dans une poêle et y faire revenir le thon environ 5 secondes de chaque côté. Couper le thon diagonalement en deux morceaux.
Fileter les agrumes. Recueillir le jus dans un saladier et assaisonner avec le sel, le sucre et la sauce de poisson. Emincer finement la citronnelle et l'incorporer.
Dresser le tartare sur les feuilles de wan-tan, poser les tranches de thon grillées côte à côte et mélanger la salade aux agrumes à la vinaigrette. Saupoudrer de ciboulette et de tandoori.

Tartar: 200 g de atún crudo (calidad para sushi); sal, pimienta; 3 cucharadas de aceite de sésamo tostado; 2 cucharadas de vinagre para sushi (vinagre de arroz); 2 cucharaditas de granos de sésamo negros y blancos respectivamente; 2 cucharaditas de cilantro fresco, picado; 8 hojas de wan-tan

Frito: 240 g de atún crudo (calidad para sushi); 1 pizca de sal; 2 cucharaditas de tandoori; aceite de sésamo para freír

Ensalada de cítricos: 2 naranjas; 1 grapefruit; 2 pomelo; 2 cucharadas de salsa de pescado clara; 1/2 palo de hierba de limón; un poco de aceite de sésamo tostado; sal, azúcar; cebollino y polvo de tandoori para adornar

Para el tartar cortar el atún a cuadritos pequeños. Sazonar con algo de sal, pimienta, aceite de sésamo tostado y vinagre para sushi. Al final añadir el cilantro y los granos de sésamo. Cortar las hojas de wan-tan en diagonal de manera que se formen dos triángulos y hacer en la freidora a 150 °C hasta dorar.
Condimentar el atún con una pizca de sal y darle la vuelta en el tandoori. Poner aceite en una sartén a fuego fuerte y freír el atún por cada lado aprox. 5 segundos. Cortar en dos trozos en diagonal.
Filetear las frutas cítricas. Recoger el zumo en un cuenco y sazonar con sal, azúcar y salsa de pescado clara. Cortar la hierba de limón a finos aros y poner debajo de los filetes.
Colocar el tartar sobre las hojas de wan-tan, poner el atún frito uno junto al otro y aderezar la ensalada de cítricos con la vinagreta. Adornar con el cebollino y el tandoori.

Tartara: 200 g di tonno crudo (qualità sushi); sale, pepe; 3 cucchiai di olio di semi di sesamo tostati; 2 cucchiai di aceto per sushi (aceto di riso); 2 cucchiaini rispettivamente di semi di sesamo nero e bianco; 2 cucchiaini di coriandolo fresco tritato; 8 sfoglie di wan tan

Frittura: 240 g di tonno crudo (qualità sushi); Pizzico di sale; 2 cucchiaini di spezie tandoori; Olio di semi di sesamo per friggere

Insalata di agrumi: 2 arance; 1 pompelmo; 2 pomeli; 2 cucchiai di salsa di pesce chiara; 1/2 gambo di erba limone; un po' di olio di semi di sesamo tostati; sale, zucchero; erba cipollina e polvere di tandoori per guarnire

Per preparare la tartara tagliate il tonno a dadini. Correggete con un po' di sale, pepe, olio di semi di sesamo tostati e aceto per sushi. Per finire, aggiungete il coriandolo e i semi di sesamo. Dividete a metà le sfoglie di wan tan, tagliandole diagonalmente e formando due triangoli, cuocetele nella friggitrice a 150 °C finché diventeranno dorate.
Condite il tonno con un pizzico di sale e passatelo nel tandoori. In una padella scaldate bene l'olio e friggetevi il tonno per ca. 5 secondi per lato. Tagliatelo diagonalmente in due pezzi.
Tagliate gli agrumi a filetti. Raccogliete il succo in una ciotola e correggete con sale e zucchero e insaporite con salsa di pesce chiara. Tagliate l'erba limone ad anellini e unitela ai filetti di agrumi.
Mettete la tartara sulle sfoglie di wan tan, accostate il tonno fritto e condite l'insalata di agrumi con la vinaigrette. Guarnite con l'erba cipollina e il tandoori.

Ederer

Chef: Karl Ederer

Kardinal-Faulhaber-Straße 10 | 80333 München | Altstadt
Phone: +49 89 24 23 13 10
restaurant-ederer@t-online.de
Subway: Marienplatz
Opening hours: Mon–Sat 11:30 am to 3 pm, 6 pm to 1 am, Sun closed
Average price: € 55
Cuisine: Creative
Special features: Reservation recommended, Gault Millau prized

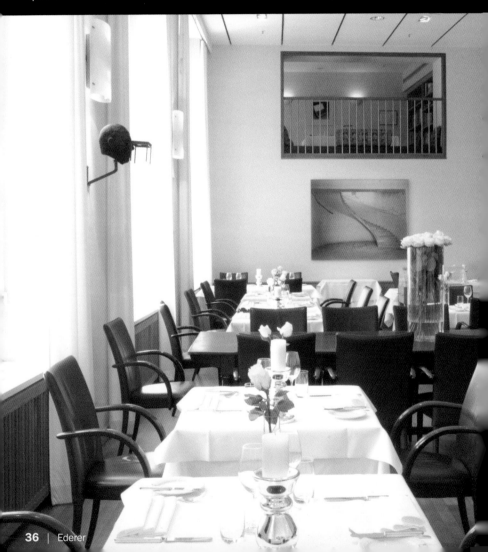

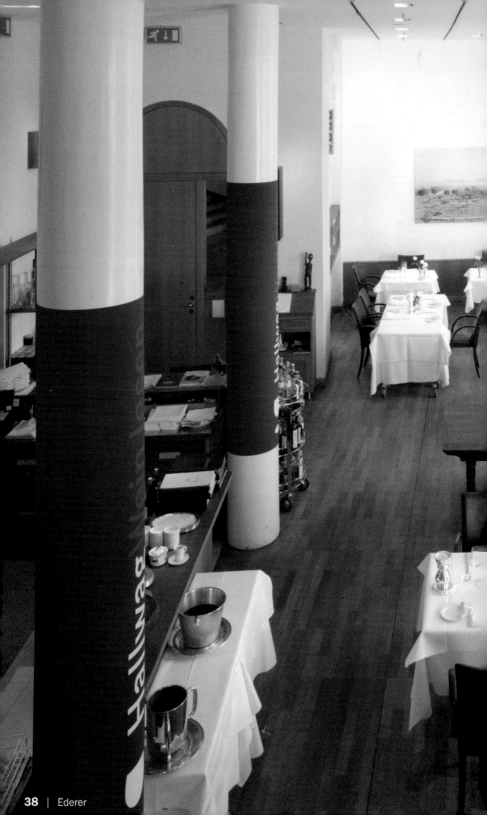

Kalbsbries

mit Balsamico-Zwetschgen und gegrillten Auberginen

Veal Sweetbread with Balsamic Plums and grilled Eggplants

Ris de veau, pruneaux au vinaigre balsamique et aubergines grillées

Lechecillas de ternera con ciruelas al Balsámico y berenjenas asadas

Animelle di vitello con prugne all'aceto balsamico e melanzane grigliate

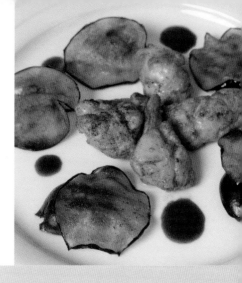

10 Zwetschgen, halbiert und entsteint
200 ml Balsamico-Essig
100 ml Wasser
Salz, Pfeffer

400 g Kalbsbries, geputzt
20 Auberginenscheiben (Ø 5–6 cm, 2–3 mm dick)
12 EL Kalbsfond
40 ml Pflanzenöl
20 g Butter
Mehl

Balsamico-Essig und Wasser aufkochen, salzen und pfeffern, über die Zwetschgen gießen und einen Tag im Kühlschrank marinieren lassen. Am nächsten Tag die Marinade (ohne Zwetschgen) nochmals aufkochen, heiß über die Zwetschgen gießen und einen weiteren Tag ziehen lassen.

Das Bries in ca. 2 cm dicke Scheiben schneiden und vorsichtig in Mehl wenden. Die Auberginenscheiben in einer Grillpfanne mit wenig Öl grillen und auf einem Tuch entfetten. Die Zwetschgen erwärmen. 2 EL der Marinade mit dem Kalbsfond einreduzieren.
In einer Pfanne das Öl und die Butter erhitzen und das Bries auf beiden Seiten goldbraun braten, jede Seite etwa 3 Minuten. Währenddessen jeweils eine Zwetschgenhälfte in eine Auberginenscheibe einschlagen.

Das Bries auf heißen Tellern anrichten, jeweils 5 Balsamico-Zwetschgen im Auberginenblatt um das Bries herumsetzen und die Sauce dazwischen verteilen. (Nicht über das Bries und die Zwetschgen geben!)

10 plums, without stone, halved
200 ml balsamic vinegar
100 ml water
Salt, pepper

14 oz veal sweetbread, cleaned
20 eggplant slices (2 inches in diameter, 0,2 inches thick)
12 tbsp veal fond
40 ml vegetable oil
2/3 oz butter
Flour

Bring balsamic vinegar and water to a boil, season with salt and pepper and pour over plums. Marinade in the refridgerator for one day. Next day bring marinade without plums to a boil and pour over plums again. Marinade in the refridgerator for another day.

Cut sweetbread into 2 cm thick slices and carefully toss with flour. Grill the eggplant slices in a grilling pan with very little oil and remove fat with a papertowl. Heat up plums. Reduce 2 tbsp plum marinade with the veal fond.
Heat oil and butter in a pan and fry sweetbread on both sides until golden brown, approx. 3 minutes on each side. In the meantime wrap each plum into one eggplant slice.

Place the sweetbread on hot plates, put five eggplant-plums on each plate and drizzle the sauce in between them. (Do not pour marinade over sweetbread and plums!)

10 pruneaux, coupés en deux et dénoyautés
200 ml de vinaigre balsamique
100 ml d'eau
Sel, poivre

400 g de ris de veau (déjà paré)
20 rondelles d'aubergine (5–6 cm de diamètre,
 2–3 mm d'épaisseur)
12 c. à soupe de fond de veau
40 ml d'huile végétale
20 g de beurre
Farine

Faire bouillir le vinaigre balsamique et l'eau, saler, poivrer, verser sur les pruneaux et laisser mariner une journée au réfrigérateur. Le jour suivant, faire bouillir encore une fois la marinade (sans les pruneaux), verser le liquide brûlant sur les pruneaux et laisser mariner un jour supplémentaire.

Couper les ris en tranches d'environ 2 cm d'épaisseur et les passer délicatement dans la farine. Faire griller les rondelles d'aubergine dans un peu d'huile et les égoutter sur un linge. Réchauffer les pruneaux. Réduire le fond de veau avec 2 c. à soupe de marinade. Chauffer de l'huile et du beurre dans une poêle et dorer les tranches de ris des deux côtés environ 3 minutes. Parallèlement, recouvrir chaque moitié de pruneau d'une rondelle d'aubergine.

Dresser les ris sur des assiettes chaudes, disposer 5 pruneaux recouverts d'une rondelle d'aubergine autour des ris et répartir la sauce entre ris et pruneaux. (Ne pas arroser les ris ni les pruneaux).

10 ciruelas, en mitades y sin hueso
200 ml de vinagre Balsámico
100 ml de agua
Sal, pimienta

400 g de lechecillas de ternera (es decir, limpias)
20 rodajas de berenjenas (de 5–6 cm de diámetro,
 de 2–3 mm de grosor)
12 cucharadas de caldo de ternera
40 ml de aceite vegetal
20 g de mantequilla
Harina

Dar un hervor al vinagre Balsámico y al agua, echar sal y pimienta, regar sobre las ciruelas y dejar marinar un día en la nevera. Al día siguiente hervir de nuevo la marinada (sin las ciruelas), regarla en caliente sobre las ciruelas y dejar reposar otro día más.

Cortar las lechecillas a rodajas de 2 cm de grosor y pasarlas por la harina con cuidado. Asar las rodajas de berenjena en una parrilla con poco aceite y desengrasar en un paño. Calentar las ciruelas. Echar 2 cucharadas de la marinada con el caldo de ternera y rebajar.
Calentar en una sartén el aceite y la mantequilla y freír las lechecillas por ambos lados hasta dorar, cada lado unos 3 minutos. Mientras tanto, meter la mitad de una ciruela en cada rodaja de berenjena.

Colocar las lechecillas en platos calientes, poner 5 ciruelas al balsámico en el manto de berenjenas respectivamente alrededor de las lechecillas y distribuir la salsa entre medio. (¡No ponerla sobre las lechecillas y las ciruelas!)

10 prugne divise a metà e snocciolate
200 ml di aceto balsamico
100 ml di acqua
Sale, pepe

400 g di animelle di vitello (ossia ripulite)
20 fette di melanzane (diam. 5–6 cm, spess.
 2–3 mm)
12 cucchiai di fondo di cottura di vitello
40 ml di olio vegetale
20 g di burro
Farina

Portate ad ebollizione l'aceto balsamico e l'acqua, salate e pepate, versate sulle prugne e fate marinare in frigorifero per un giorno. Il giorno dopo portate di nuovo ad ebollizione la marinata (senza prugne), versatela ancora bollente sulle prugne e fate macerare un altro giorno.

Tagliate le animelle a fette spesse ca. 2 cm e passatele con cautela nella farina. Grigliate le fette di melanzane in una padella a griglia con poco olio d'oliva e sgrassatele su un canovaccio. Riscaldate le prugne. Fate ridurre 2 cucchiai di marinata con il fondo di cottura di vitello.
In una padella scaldate l'olio e il burro e friggete le animelle su entrambi i lati per circa 3 minuti finché diventeranno di un colore ben dorato. Nel frattempo avvolgete in ciascuna fetta di melanzana una metà di prugna.

Mettete le animelle su piatti molto caldi, disponete intorno 5 prugne all'aceto balsamico avvolte in foglia di melanzana e distribuite in mezzo la salsa. (Non mettete la salsa sulle animelle e sulle prugne!)

Emporio Armani Caffè

Design: Inhouse Giorgio Armani | Chef: Marco Beccalli

Theatinerstraße 12 | 80333 München | Altstadt
Phone: +49 89 20 80 22 08
www.emporioarmani.com | info@armanicaffe.de
Subway: Marienplatz, Odeonsplatz
Opening hours: Every day 10 am to 12 midnight
Average price: € 20
Cuisine: Italian
Special features: Celeb hangout, bar scene

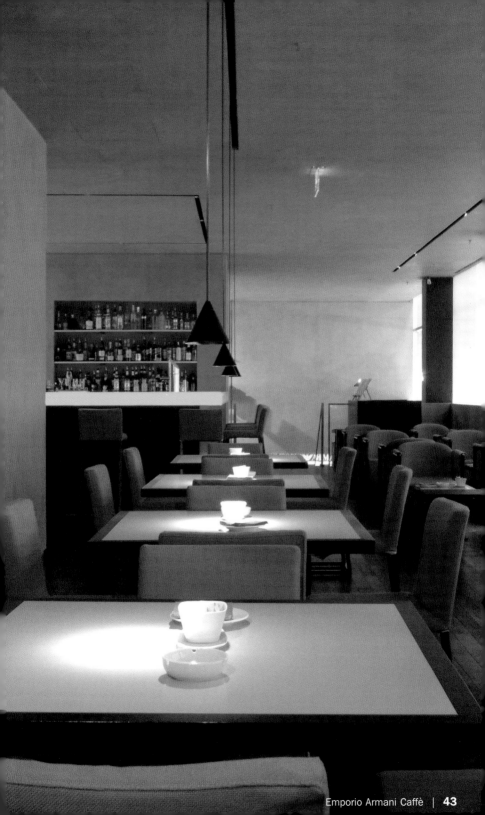

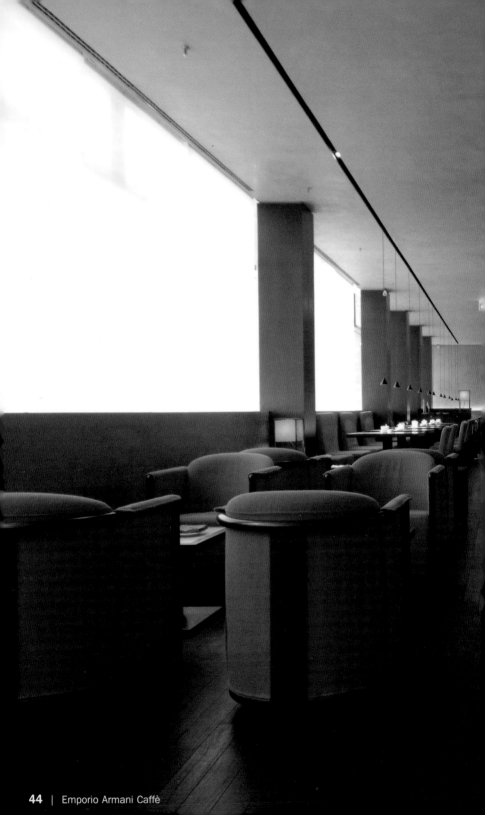

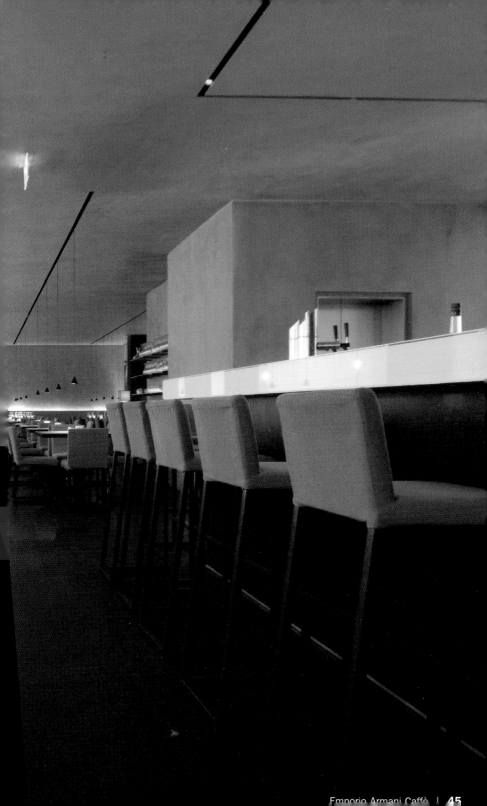

Knurrhahn

mit Thymiankartoffelgratin und Austernsauce

Gurnard with Thyme Potatoe Gratin and
Oystersauce

Grondin et gratin de pommes de terre au
thym, sauce aux huîtres

Gallina de mar con gratinado de patatas y
tomillo en salsa de ostras

Capone con gratin di patate al timo e salsa
alle ostriche

16 kleine Kartoffeln
3 Zweige Thymian

8 Austern
100 ml Weißwein
2 EL Olivenöl
1 Staudensellerie, in Scheiben
1 Knoblauchzehe
Salz, Pfeffer

4 Knurrhahnfilets à 150 g
100 ml Weißwein
2 EL Olivenöl
2 Zweige Thymian
1 Knoblauchzehe
Salz, Pfeffer

Kartoffeln schälen, in dünne Scheiben schneiden
und mit dem gehackten Thymian in vier kleine,
gefettete Auflaufformen schichten. Mit Alufolie
abdecken und bei 180 °C ca. 20 Minuten
backen.
In einem Topf Weißwein, Olivenöl, Sellerie,
Knoblauch, Salz und Pfeffer erhitzen und die
Austern hineingeben. Wenn sich die Austern
öffnen, herausnehmen und den Fond beiseite
stellen. Die Austern warm halten und den Fond
abschmecken. Die entgräteten Knurrhahnfilets
in einem Topf mit Weißwein, Olivenöl, Thymian,
Knoblauch, Salz und Pfeffer 5–6 Minuten
pochieren.
Die Gratins aus den Formen lösen und in der
Mitte des Tellers platzieren. Je ein Knurrhahnfilet
darauf setzen, die Austern darum verteilen und
mit dem Austernfond beträufeln.

16 small potatoes
3 twigs thyme

8 oysters
100 ml white wine
2 tbsp olive oil
1 celery, sliced
1 clove garlic
Salt, pepper

4 filets of gurnard 150 g each
100 ml white wine
2 tbsp olive oil
2 twigs thyme
1 clove garlic
Salt, pepper

Peel potatoes, cut in thin slices and stack with
chopped thyme in four small, greased baking
dishes. Cover with aluminium foil and bake in
oven at 360 °F for 20 minutes.
Bring wine, olive oil, celery, garlic, salt and pepper
to a boil and add oysters. When the oysters open,
remove from pot and set fond aside. Keep oysters
warm and season fond for taste. Poach gurnard
filets in a pot with wine, olive oil, thyme, garlic,
salt and pepper for approx. 5–6 minutes.
Remove gratins from the baking dish and place
in the middle of the plates. Put one gurnard filet
on top and place oysters around them. Sprinkle
with oyster fond.

16 petites pommes de terre
3 brins de thym

8 huîtres
100 ml de vin blanc
2 c. à soupe d'huile d'olive
1 céleri en branches, coupé en rondelles
1 gousse d'ail
Sel, poivre

4 filets de grondin à 150 g
100 ml de vin blanc
2 c. à soupe d'huile d'olive
2 brins de thym
1 gousse d'ail
Sel, poivre

Eplucher les pommes de terre, les couper en fines rondelles et les superposer avec le thym haché dans quatre petits moules à gratin graissés. Recouvrir avec du papier aluminium et enfourner à 180 °C environ 20 minutes.
Mettre dans une casserole le vin blanc, l'huile d'olive, le céleri, l'ail, le sel et le poivre, porter à ébullition et ajouter les huîtres. Quand les huîtres s'ouvrent, les sortir de la casserole et mettre le fond de côté. Réserver au chaud les huîtres. Rectifier l'assaisonnement du fond. Pocher 5 à 6 minutes les filets de grondin sans arêtes dans une casserole avec du vin blanc, de l'huile d'olive, du thym, de l'ail, du sel et du poivre.
Sortir les gratins des moules et les dresser au centre des assiettes. Déposer sur chacun d'eux un filet de grondin, parsemer d'huîtres et arroser avec le fond.

16 patatas pequeñas
3 ramas de tomillo

8 ostras
100 ml de vino blanco
2 cucharadas de aceite de oliva
1 apio en rama, a rodajas
1 diente de ajo
Sal, pimienta

4 filetes de gallina de mar de 150 g cada uno
100 ml de vino blanco
2 cucharada de aceite de oliva
2 ramas de tomillo
1 diente de ajo
Sal, pimienta

Pelar las patatas, cortarlas a rodajas delgadas y apilarlas con el tomillo picado en cuatro moldes pequeños para horno engrasados. Tapar con papel de aluminio y hornear a 180 °C aprox. 20 minutos.
Calentar en una olla el vino blanco, el aceite de oliva, el apio, el ajo, la sal y la pimienta y añadir las ostras. Cuando las ostras se abran sacarlas y poner el caldo aparte. Mantener calientes las ostras y sazonar el caldo concentrado. Escalfar los filetes de gallina de mar sin espinas en una olla con el vino blanco, el aceite de oliva, el tomillo, el ajo, la sal y la pimienta durante 5–6 minutos.
Sacar los gratinados de los moldes y colocarlos en el centro de los platos. Poner cada filete de gallina de mar en un plato, distribuir las ostras por él y rociar con el caldo concentrado de ostras.

16 patate piccole
3 rametti di timo

8 ostriche
100 ml di vino bianco
2 cucchiai di olio d'oliva
1 gambo di sedano a fette
1 spicchio d'aglio
Sale, pepe

4 filetti di capone da 150 g
100 ml di vino bianco
2 cucchiai di olio d'oliva
2 rametti di timo
1 spicchio d'aglio
Sale, pepe

Pelate le patate, tagliatele a fette sottili e disponetele a strati con il timo tritato in quattro piccoli stampi per sformati precedentemente unti. Coprite con carta alluminio e cuocete in forno per ca. 20 minuti a 180 °C.
In un tegame scaldate il vino bianco, l'olio d'oliva, il sedano, l'aglio, il sale e il pepe e aggiungetevi le ostriche. Non appena le ostriche saranno aperte, toglietele dal tegame e mettete da parte il fondo di cottura. Tenete le ostriche in caldo e correggete il condimento del fondo di cottura. In un tegame fate sobbollire i filetti di capone spinato con il vino bianco, l'olio d'oliva, il timo, l'aglio, il sale e il pepe per 5–6 minuti.
Togliete dagli stampi le patate gratinate e disponetele al centro dei piatti. Sistematevi sopra un filetto di capone, distribuite intorno le ostriche e versatevi alcune gocce del fondo di cottura delle ostriche.

Essneun Restaurant + Bar

Design: Marita Nagel | Chef: Bernd Arold

Hans-Sachs-Straße 9 | 80469 München | Ludwigsvorstadt-Isarvorstadt
Phone: +49 89 23 23 09 35
www.essneun.de
Subway: Sendlinger Tor
Opening hours: Mon–Thu 7 pm to 1 am, Fri–Sat 7 pm to 2 am
Cuisine: Freestyle kitchen
Special features: Reservation recommended, hot spot for creative people, celeb hangout

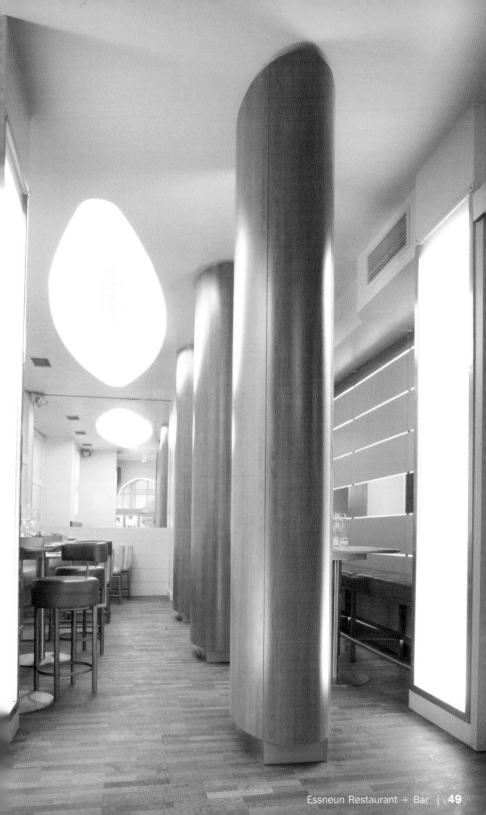

Teewurst-Dattel-Ravioli

mit Senfsaibling und Papayagurke

Smoked Pork Sausage Spread Date Ravioli with Mustard Lake Trout and Papaya Pickles

Ravioli aux dattes et à la Teewurst, omble de fontaine et papaye

Ravioles de embutido ahumado y dátiles con salvelino a la mostaza y pepinillo con papaya

Ravioli al Teewurst e ai datteri con salmerino alla senape e cetriolo alla papaia

Ravioliteig: 300 g Mehl; 3 Eier; 1 Packung Fishermen's Friends (gemahlen); 50 g Kräuterbutter

Raviolifüllung: 100 g Teewurst (grob); 50 g Datteln, gehackt; 1 rote Zwiebel, gehackt; 10 Oliven, gehackt; 10 getrocknete Tomaten, gehackt; 10 g Pinienkerne, gehackt; 3 EL Parmesan, gerieben; Salz, Pfeffer, Zucker, Curry

50 g Kürbis, in Würfeln; 50 g Trauben; 50 g Mandarinen; 4 Stück Senfgurken, geviertelt; 1 Papaya; 3 EL Dijon-Senf; 50 g Erdnüsse, geröstet; 1 Zweig Rosmarin; 2 Zweige Thymian; Salz, Pfeffer

2 Stangen Frühlingslauch; 1 Paprika, in Stücken

Senfsaibling: 4 Bachsaiblingsfilets; Senfkörner zum Panieren; 2 EL Butter; Salz, Pfeffer

Die Zutaten für den Ravioliteig vermengen und den Teig ausrollen, Zutaten für die Füllung mischen und abschmecken. Die Füllung auf den Teig geben und viereckige Ravioli formen. In siedendem Salzwasser gar ziehen lassen.
Kürbis blanchieren und mit den Trauben, Mandarinen, Senfgurken und Papayastücken mischen. Aus Senf, Erdnüssen, gehacktem Rosmarin und Thymian, Salz und Pfeffer eine Vinaigrette bereiten und unterheben. Frühlingslauch und Paprika blanchieren.
Den Bachsaibling würzen, in Senfkörnern wälzen und in etwas Butter von jeder Seite ca. 2 Minuten braten.
Auf einem Teller den Frühlingslauch und die Paprika anrichten, den Saibling und die Ravioli darauf geben und das marinierte Gemüse darum verteilen.

Ravioli dough: 10 1/2 oz flour; 3 eggs; 1 package Fishermen's Friend (grounded); 1 1/2 oz herb butter

Ravioli filling: 3 1/2 oz smoked pork sausage spread; 1 1/2 oz dates, chopped; 1 red onion, chopped: 10 olives, chopped; 10 dried tomatoes, chopped; 1/3 oz pine nuts, chopped; 3 tbsp grated Parmesan cheese; salt, pepper, sugar, curry

1 1/2 oz pumpkin, in cubes; 1 1/2 oz grapes; 1 1/2 oz tangerines; 4 pieces of pickled gherkin with mustard seeds, in quarters; 1 papaya; 3 tbsp Dijon mustard; 1 1/2 oz roasted peanuts; 1 twig rosemary; 2 twigs thyme; salt, pepper

2 spring onions; 1 bell pepper, in pieces

Lake Trout: 4 filets of lake trout; mustard seeds for breading; 2 tbsp butter; salt, pepper

Mix ingredients for the dough and roll out. Mix ingredients for the filling and season for taste. Place filling on the dough and shape into square raviolis. Cook in boiling salted water until done.
Blanch pumpkin cubes and mix with grapes, tangerines, gherkin and papaya pieces. Make a vinaigrette with mustard, peanuts, rosemary, thyme, salt and pepper and fold under vegetables. Blanch spring onions and bell pepper.
Season lake trout, toss in mustard seeds and fry in butter on each side for 2 minutes.
Place spring onions and bell pepper on a plate, put lake trout and raviolis on top and garnish with marinated vegetables.

Pâte à ravioli : 300 g de farine ; 3 œufs ; 1 sachet de Fishermen's Friends (moulu) ; 50 g de beurre aux herbes

Farce à ravioli : 100 g de Teewurst (saucisse fumée à tartiner – gros grains) ; 50 g de dattes hachées ; 1 oignon rouge haché ; 10 olives hachées ; 10 tomates séchées hachées ; 10 g de pignons hachés ; 3 c. à soupe de parmesan râpé ; sel, poivre, sucre, curry

50 g de potiron en dés ; 50 g de raisins ; 50 g de mandarines ; 4 concombres marinés, coupés en quatre ; 1 papaye ; 3 c. à soupe de moutarde de Dijon ; 50 g de cacahuètes grillées ; 1 brin de romarin ; 2 brins de thym ; sel, poivre

2 ciboules ; 1 poivron coupé en morceaux

Omble de fontaine : 4 filets d'omble ; graines de moutarde pour la panade ; 2 c. à soupe de beurre ; sel, poivre

Mélanger les ingrédients pour faire la pâte à ravioli, étendre la pâte, mélanger les ingrédients pour la farce et rectifier l'assaisonnement. Etaler la farce sur la pâte, découper des carrés et façonner les ravioli. Les faire cuire à l'eau salée bouillante.
Blanchir le potiron et mélanger les raisins, les mandarines, les concombres et la papaye. Préparer une vinaigrette avec la moutarde, les cacahuètes, le romarin et le thym hachés, le sel et le poivre. Incorporer la vinaigrette. Blanchir la ciboule et le poivron.
Assaisonner les filets d'omble, les passer dans les graines de moutarde et les faire revenir de chaque côté avec un peu de beurre environ 2 minutes.
Dresser la ciboule et le poivron sur une assiette, poser dessus l'omble et les ravioli et garnir de légumes marinés.

Pasta de los ravioles: 300 g de harina; 3 huevos; 1 paquete de Fishermen's Friends (molidos); 50 g de mantequilla de hierbas

Relleno de los ravioles: 100 g de embutido ahumado (grueso); 50 g de dátiles, picados; 1 cebolla roja, picada; 10 olivas, picadas; 10 tomates secos, picados; 10 g de piñones, picados; 3 cucharadas de parmesano, rallado; sal, pimienta, azúcar, curry

50 g de calabaza, a cuadritos; 50 g de uvas; 50 g de mandarinas; 4 pepinillos en vinagre y mostaza, cortados a cuartos; 1 papaya; 3 cucharadas de mostaza de Dijon; 50 g de cacahuetes, tostados; 1 rama de romero; 2 ramas de tomillo; sal, pimienta

2 palos de cebolla de puerro; 1 pimiento, a trozos

Salvelino a la mostaza: 4 filetes de salvelinos de río; granos de mostaza para rebozar; 2 cucharadas de mantequilla; sal, pimienta

Mezclar los ingredientes para la pasta de ravioles y enrollar la pasta, mezclar los ingredientes para el relleno y sazonar. Poner el relleno en la masa y formar ravioles cuadrados. Dejar reposar cocidos en agua hirviendo con sal.
Escaldar la calabaza y mezclar con las uvas, las mandarinas, los pepinillos en vinagre y mostaza y los trozos de papaya. Preparar una vinagreta con la mostaza, los cacahuetes, el romero picado y el tomillo, la sal y la pimienta e incorporar. Escaldar el puerro y el pimiento.
Aliñar el salvelino de río, rebozar con granos de mostaza y freír en algo de mantequilla aprox. 2 minutos por cada lado.
Colocar en un plato el puerro y el pimiento, poner encima el salvelino y los ravioles y esparcir por ellos la verdura marinada.

Pasta per i ravioli: 300 g di farina; 3 uova; 1 confezione di Fishermen's Friends (macinate); 50 g di burro alle erbe

Ripieno per i ravioli: 100 g di Teewurst (salume affumicato spalmabile) ad impasto grosso; 50 g di datteri tritati; 1 cipolla rossa tritata; 10 olive tritate; 10 pomodori secchi tritati; 10 g di pinoli tritati; 3 cucchiai di parmigiano grattugiato; sale, pepe, zucchero, curry

50 g di zucca a dadini; 50 g di uva; 50 g di mandarini; 4 pezzi di cetriolo ai semi di senape divisi in quattro; 1 papaia; 3 cucchiai di senape di Digione; 50 g di arachidi tostate; 1 rametto di rosmarino; 2 rametti di timo; sale, pepe

2 gambi di cipolletta; 1 peperone a pezzetti

Salmerino alla senape: 4 filetti di salmerino di fontana; semi di senape per impanare; 2 cucchiai di burro; sale, pepe

Mescolate bene gli ingredienti per la pasta per i ravioli e spianate la pasta, mescolate gli ingredienti per il ripieno e correggetene il condimento. Mettete il ripieno sulla pasta e formate dei ravioli quadrati. Lasciate cuocere in acqua salata bollente.
Sbollentate la zucca e mescolatela con l'uva, i mandarini, il cetriolo ai semi di senape e i pezzetti di papaia. Preparate una vinaigrette con senape, arachidi, rosmarino e timo tritati, sale e pepe e incorporatela. Sbollentate la cipolletta e il peperone.
Condite il salmerino di fontana, rotolatelo nei semi di senape, friggetelo in un po' di burro per ca. 2 minuti per lato.
Mettete su un piatto la cipolletta e il peperone, sistematevi sopra il salmerino e i ravioli e distribuite intorno la verdura marinata.

Falk's Bar

Design: Sigwart Graf Pilati | Chef: Holger Keller

Promenadeplatz 2–6 | 80333 München | Altstadt
Phone: +49 89 2 12 09 56
www.bayerischerhof.de | info@bayerischerhof.de
Subway: Marienplatz, Odeonsplatz
Opening hours: Every day 11 am to 2 am
Average price: € 15
Special features: Reservation recommended, celeb hangout, bar scene,
Gault Millau prized

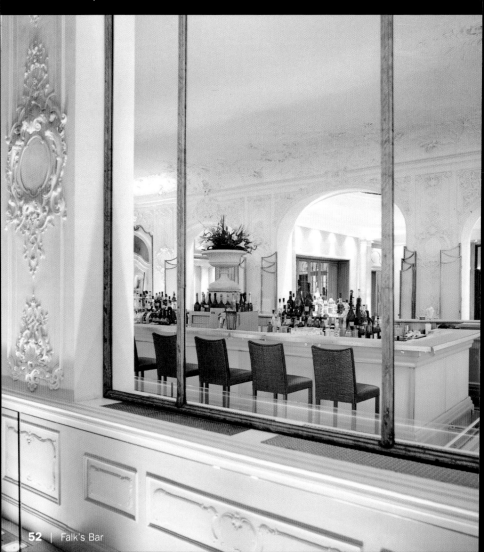

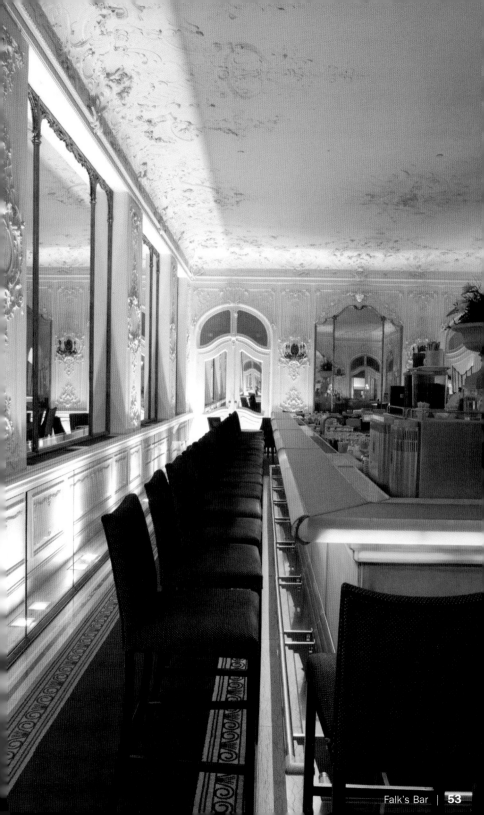

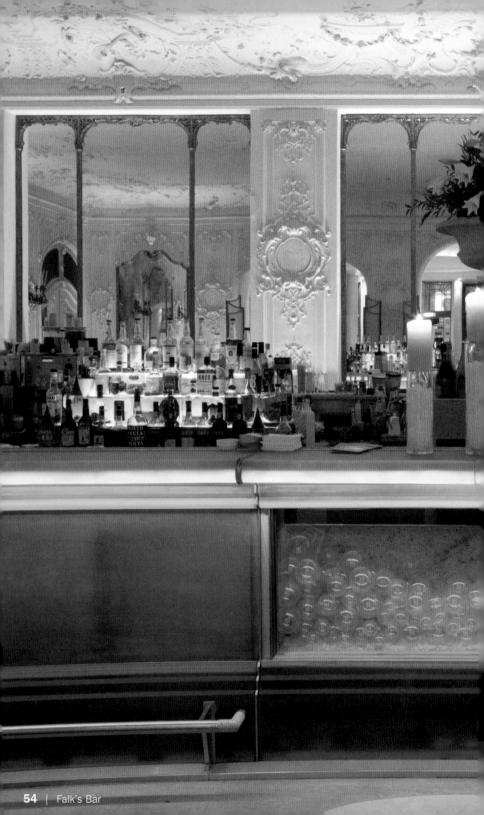

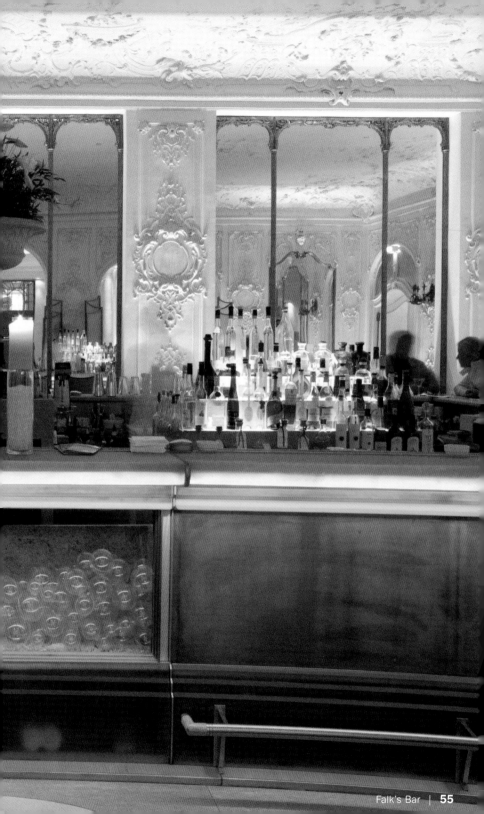

Glockenspiel
Cafe Restaurant Bar
Design: Jürgen Rosner | Chef: Sven Ulmer

Marienplatz 28 | 80331 München | Altstadt
Phone: +49 89 26 42 56
www.cafe-glockenspiel.de | welcome@cafe-glockenspiel.de
Subway: Marienplatz, Odeonplatz
Opening hours: Every day 10 am to 1 pm, kitchen open 10 am to 23:30 pm
Average price: € 15
Cuisine: Contemporary
Special features: Bar scene, private rooms

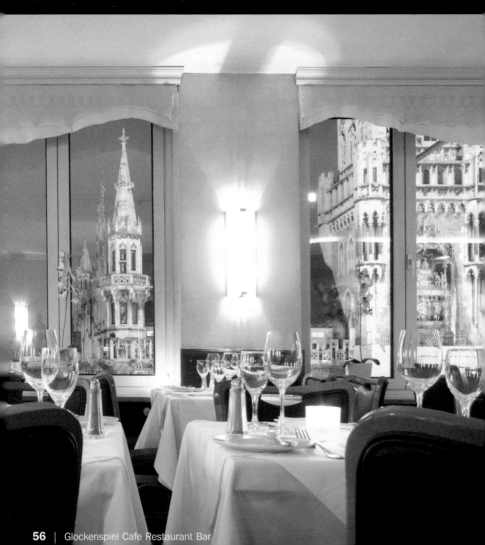

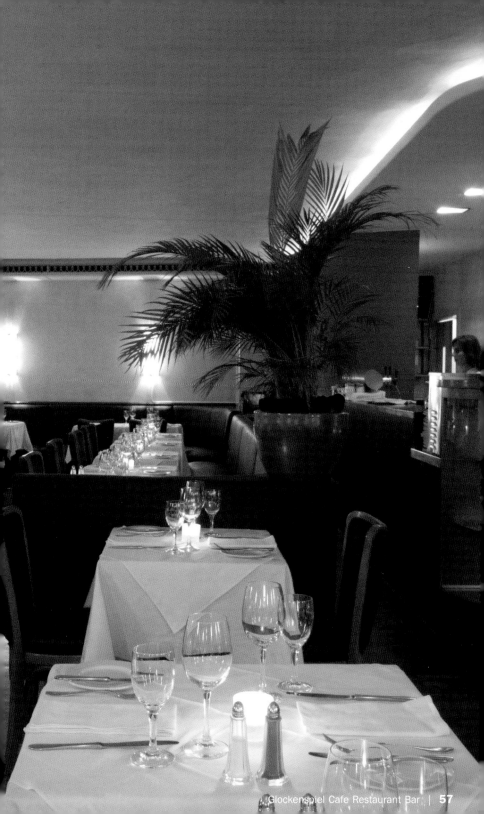

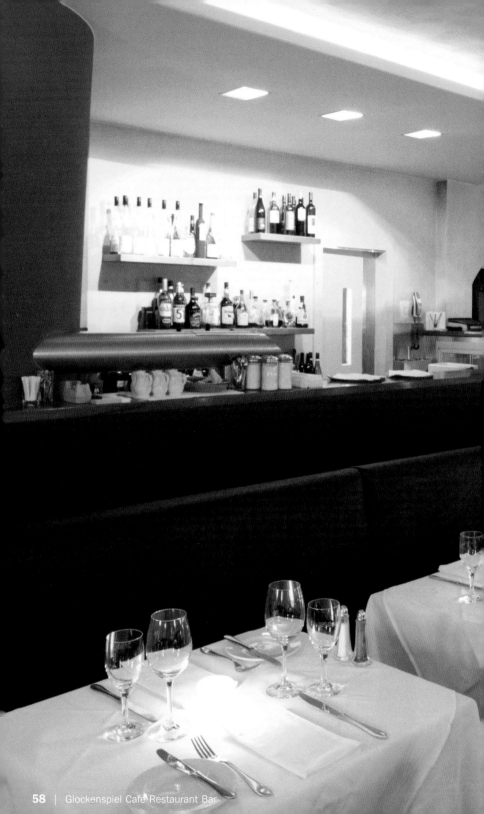

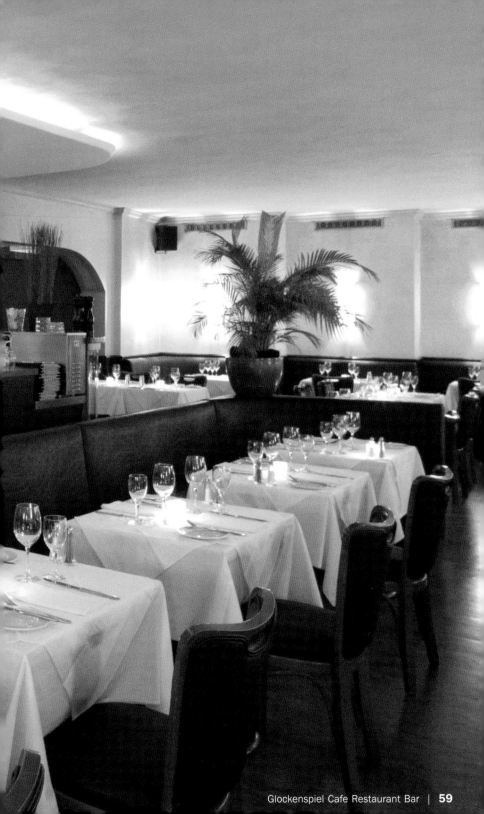

Glockenspiel Cafe Restaurant Bar | **59**

Mühlbaurstraße 5 | 80677 München | Bogenhausen
Phone: +49 89 47 58 55
Subway: Prinzregentenplatz
Opening hours: Every day 12 noon to 2 pm, 6:30 pm to 12 midnight
Average price: € 30
Cuisine: Italian
Special features: Reservation recommended, Gault Millau prized

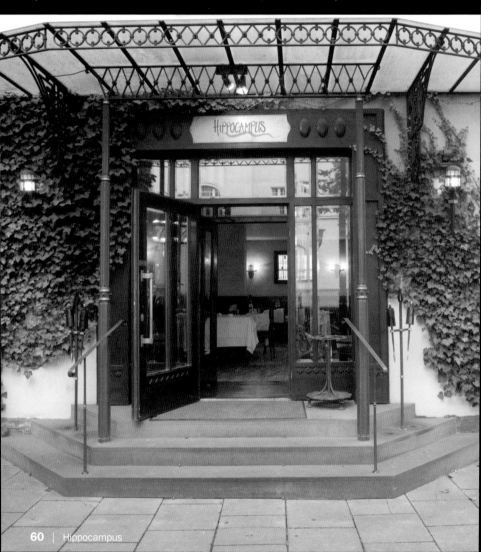

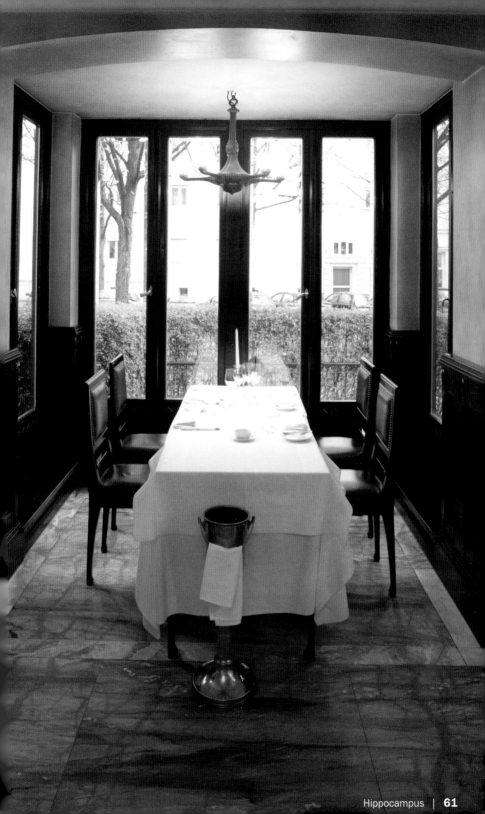

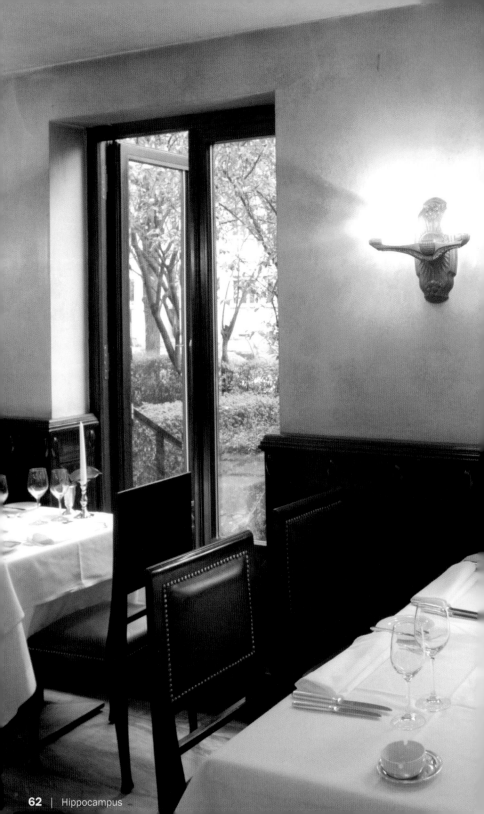

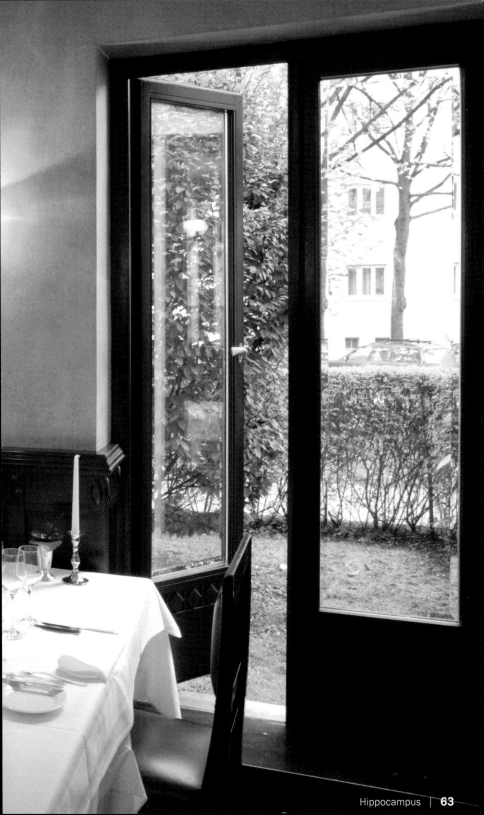

Landersdorfer & Innerhofer

Chef: Hans Landersdorfer

Hackenstraße 6–8 | 80331 München | Altstadt
Phone: +49 89 26 01 86 37
Subway: Marienplatz, Sendlinger Tor
Opening hours: Mon–Fri 11:30 am to 2:30 pm, 6:30 pm to 1 am, closed on weekend
Average price: € 50
Cuisine: Modern Austrian
Special features: Reservation recommended, Gault Millau prized

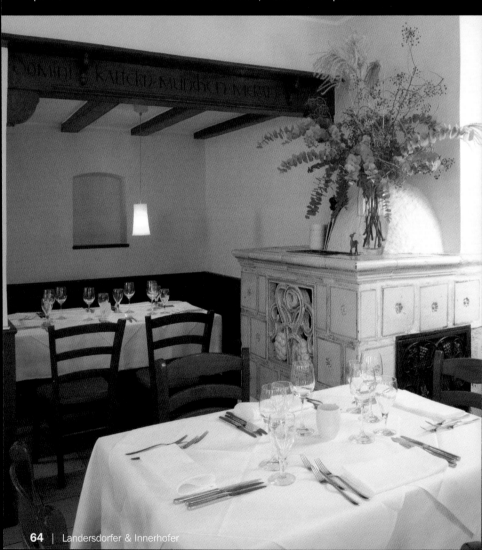

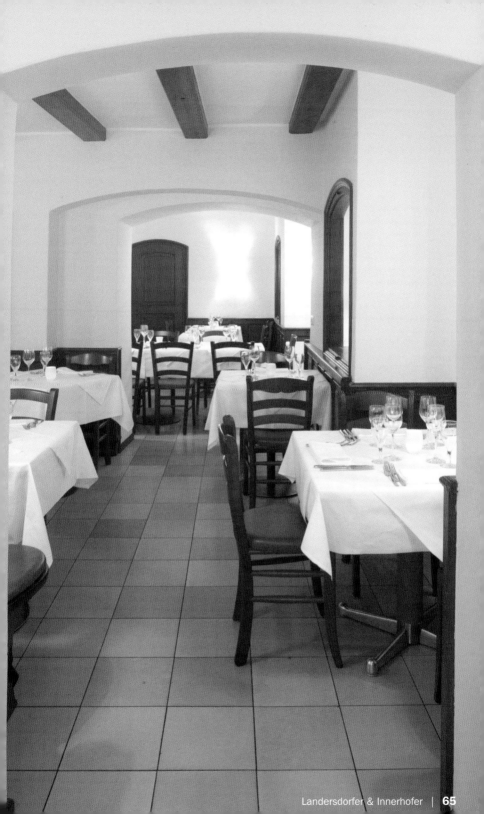

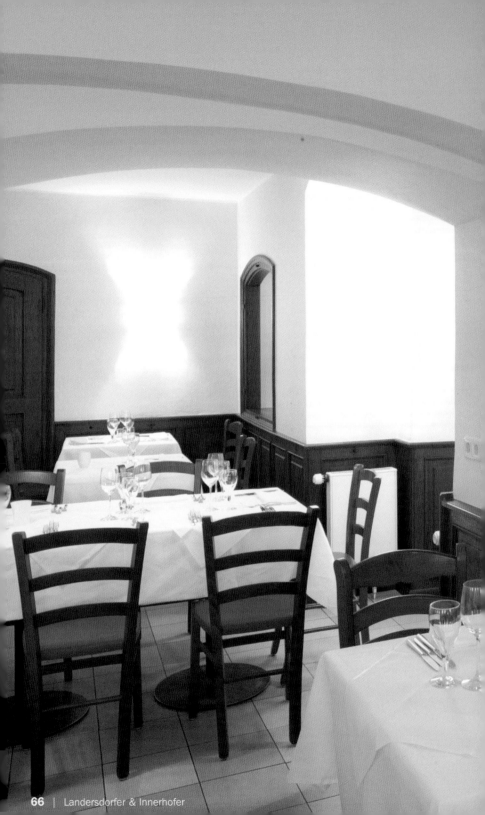

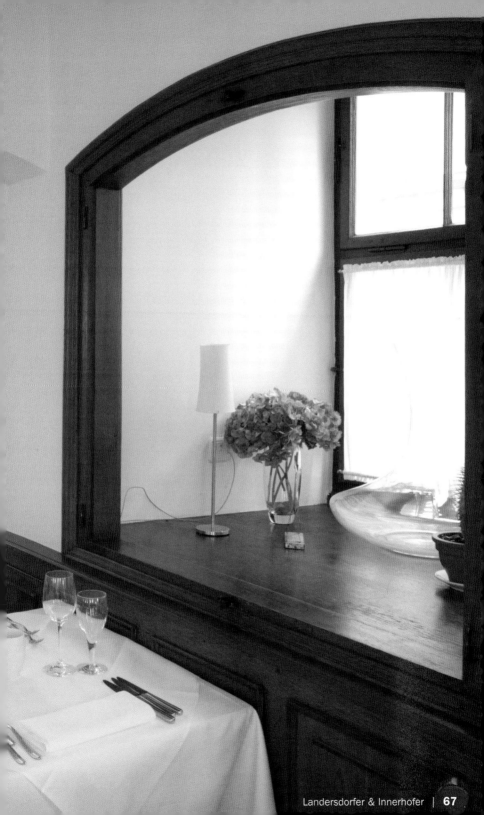

Lenbach

Design: Sir Terence Conran | Chef: Ali Güngörmüs

Ottostraße 6 | 80333 München | Altstadt
Phone: +49 89 5 49 13 00
www.lenbach.de | info@lenbach.de
Subway: Karlsplatz / Stachus
Opening hours: Mon–Fri 11:30 am to 2:30 pm, 6 pm to 1 am, Sat 6 pm to 1 am,
Sun closed
Cuisine: Mediterranean
Special features: Reservation recommended, celeb hangout, Gault Millau prized

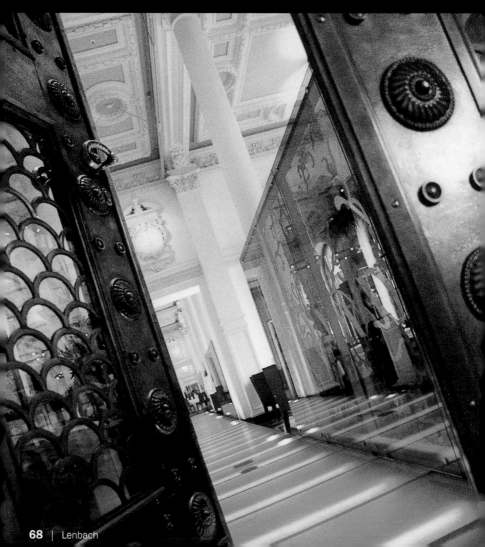

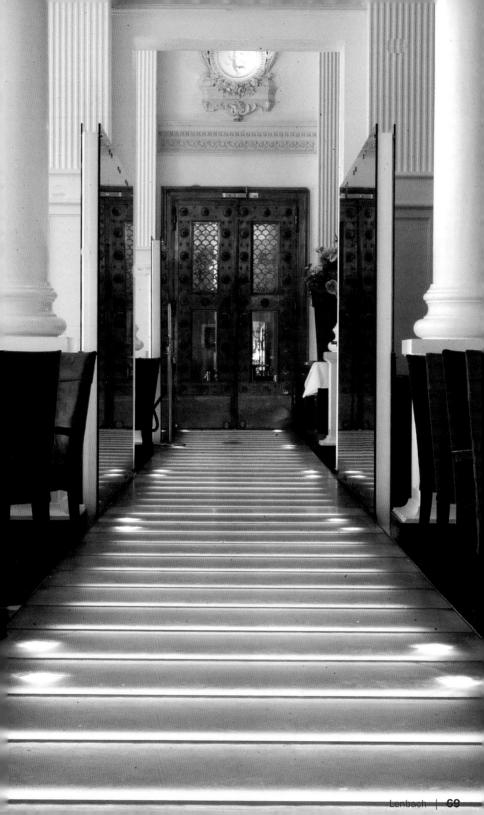

Wolfsbarsch

mit Hummerkroketten auf Orangenlinsen

Sea bass with Lobster Croquettes and Orange Lentils

Loup de mer et croquettes de homard sur lentilles à l'orange

Lubina con croquetas de bogavante y lentejas a la naranja

Spigola con crocchette di astice su lenticchie all'arancia

3 Schalotten
2 Knoblauchzehen
3 EL Olivenöl
200 g grüne Linsen
100 ml Tomatensaft
100 ml Geflügelbrühe
200 ml Orangensaft
1 Zweig Thymian und Rosmarin
50 g Butter
Salz, Pfeffer, Zucker

Für die Hummerkroketten:
500 g gekochte, passierte Kartoffeln
3 Eigelb
25 g Butter
100 g gekochtes Hummerfleisch
Salz, Pfeffer, Muskat
1 Ei, Mehl und Semmelbrösel für die Panade

8 Stücke Wolfsbarschfilet à 50 g
Saft einer Zitrone
3 EL Olivenöl, Salz

Die Schalotten in feine Würfel schneiden und mit dem Knoblauch in Olivenöl anschwitzen. Die Linsen dazugeben und mit Tomatensaft, Geflügelbrühe und Orangensaft auffüllen. Thymian und Rosmarin dazugeben und solange kochen, bis die Linsen weich sind. Die kalte Butter einrühren und mit Salz, Pfeffer und etwas Zucker abschmecken.
Für die Kroketten die passierten Kartoffeln mit den Eigelben, der Butter und dem kleingeschnittenen Hummer vermischen und mit Salz, Pfeffer und Muskat würzen. Mit dem Spritzbeutel die Masse in 4 cm lange Stränge aufspritzen, panieren und in Öl goldgelb backen.
Den Fisch mit Salz und Zitronensaft würzen, in Olivenöl anbraten und auf den Orangenlinsen mit Hummerkroketten servieren.

3 shallots
2 cloves garlic
3 tbsp olive oil
7 oz green lentils
100 ml tomato juice
100 ml chicken stock
200 ml orange juice
1 twig thyme and rosemary
1 1/2 oz butter
Salt, pepper, sugar

For the lobster croquettes:
18 oz cooked and mashed potatoes
3 egg yolks
1 oz butter
3 1/2 oz lobster meat, cooked
Salt, pepper, nutmeg
1 egg, flour and breadcrumbs for breading

8 pieces of sea brass, 1 1/2 oz each
Juice of 1 lemon
3 tbsp olive oil, salt

Cut shallots in small cubes and sauté with garlic in olive oil. Add lentils, tomato juice, chicken stock and orange juice. Add thyme and rosemary and simmer until lentils are tender. Stir in cold butter and season with salt, pepper and sugar.
For the croquettes combine mashed potatoes with egg yolks, butter, lobster and season with salt, pepper and nutmeg. Shape the mixture with a piping bag into 4 cm long pieces, bread and deep-fry in hot oil until goldenbrown.
Season fish with salt and lemon juice, fry in hot olive oil and serve with lobster croquettes and lentils.

3 échalotes
2 gousses d'ail
3 c. à soupe d'huile d'olive
200 g de lentilles vertes
100 ml de jus de tomate
100 ml de bouillon de volaille
200 ml de jus d'orange
1 brin de thym et de romarin
50 g de beurre
Sel, poivre, sucre

Pour les croquettes de homard :
500 g de pommes de terre cuites et passées
3 jaunes d'œuf
25 g de beurre
100 g de chair de homard
Sel, poivre, muscade
1 œuf, de la farine et de la chapelure pour la panade

8 morceaux de filet de lieu de mer à 50 g
Jus d'un citron
3 c. à soupe d'huile d'olive, sel

Couper finement les échalotes en dés et faire revenir avec l'ail dans l'huile d'olive. Ajouter les lentilles, puis le jus de tomate, le bouillon de volaille et le jus d'orange. Ajouter le thym et le romarin et laisser cuire. Incorporer le beurre froid et assaisonner avec le sel, le poivre et un peu de sucre.
Pour les croquettes, mélanger les pommes de terre passées avec les jaunes d'œuf, le beurre et le homard coupé en petites bouchées, assaisonner avec le sel, le poivre et la muscade. Mettre la préparation dans une poche à douille et former des bandes de 4 cm de long, les paner et les faire dorer dans l'huile.
Assaisonner le poisson avec le sel et le jus de citron, le faire revenir dans l'huile d'olive et le servir sur les lentilles à l'orange avec les croquettes de homard.

3 chalotes
2 dientes de ajo
3 cucharadas de aceite de oliva
200 g de lentejas verdes
100 ml de zumo de tomate
100 ml de caldo de ave
200 ml de zumo de naranja
1 rama de tomillo y de romero
50 g de mantequilla
Sal, pimienta, azúcar

Para las croquetas de bogavante:
500 g de patatas cocidas, tamizadas
3 yemas de huevo
25 g mantequilla
100 g de carne de bogavante cocido
Sal, pimienta, nuez moscada
1 huevo, harina y pan rallado para rebozar

8 filetes de lubina de 50 g cada uno
El zumo de un limón
3 cucharadas de aceite de oliva, sal

Cortar los chalotes a cuadritos finos y dorar en aceite de oliva con el ajo. Añadir las lentejas y completar con el zumo de tomate, el caldo de ave y el zumo de naranja. Añadir el tomillo y el romero y cocer hasta que las lentejas estén blandas. Mezclar la mantequilla fría y sazonar con sal, pimienta y algo de azúcar.
Para las croquetas mezclar las patatas tamizadas con las yemas de los huevos, la mantequilla y el bogavante cortada a trozos pequeños y condimentar con sal, pimienta y nuez moscada. Echar la masa con la manga a chorros de 4 cm de largo, rebozar y cocinar en aceite hasta dorar.
Condimentar el pescado con sal y el zumo de limón, freír en aceite de oliva y servir encima de las lentejas a la naranja con las croquetas de langosta.

3 scalogni
2 spicchi d'aglio
3 cucchiai di olio d'oliva
200 g di lenticchie verdi
100 ml di succo di pomodoro
100 ml di brodo di pollo
200 ml di succo d'arancia
1 rametto di timo e rosmarino
50 g di burro
Sale, pepe, zucchero

Per le crocchette di astice:
500 g di patate lessate e passate
3 tuorli d'uovo
25 g di burro
100 g di polpa di astice lessata
Sale, pepe, noce moscata
1 uovo, farina e pangrattato per l'impanatura

8 pezzi di filetto di spigola da 50 g
Succo di un limone
3 cucchiai di olio d'oliva, sale

Tagliate gli scalogni a dadini e fateli dorare con l'aglio nell'olio d'oliva. Aggiungete le lenticchie e colmate con succo di pomodoro, brodo di pollo e succo d'arancia. Aggiungete il timo e il rosmarino e fate cuocere finché le lenticchie saranno tenere. Incorporate il burro freddo e correggete con sale, pepe e un po' di zucchero.
Per le crocchette mescolate le patate passate con i tuorli d'uovo, il burro e l'astice tagliato finemente e condite con sale, pepe e noce moscata. Con la siringa per dolci formate con l'impasto matassine lunghe 4 cm, impanatele e cuocetele nell'olio finché diventeranno dorate.
Condite il pesce con sale e succo di limone, fatelo rosolare nell'olio d'oliva e servitelo sulle lenticchie all'arancia con crocchette di astice.

Lounge₂

Design: Architekturbüro Schmidhuber & Partner
Chef: Ernesto Lechthaler

Bayerstraße 3–5 | 80335 München | Ludwigsvorstadt-Isarvorstadt
Phone: +49 89 51 26 22 22
www.l-lounge2.de | munich@l-lounge2.de
Subway: Hauptbahnhof, Karlsplatz / Stachus
Opening hours: Every day 5 pm to 4 pm
Cuisine: Contemporary
Special features: Drinks and Fingerfood

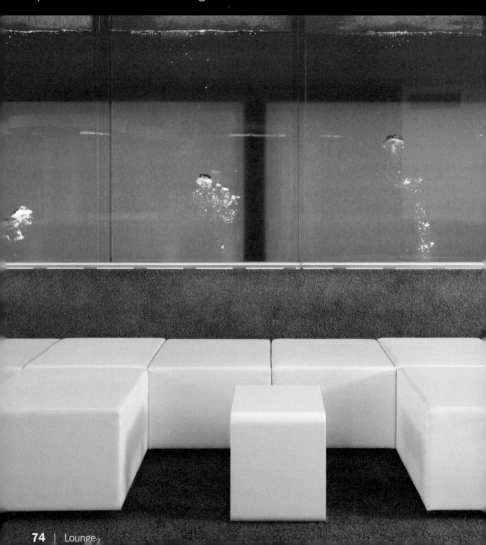

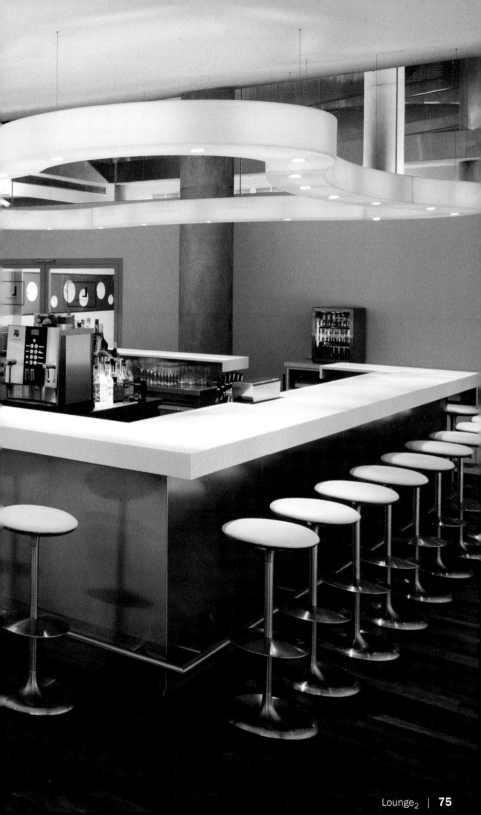

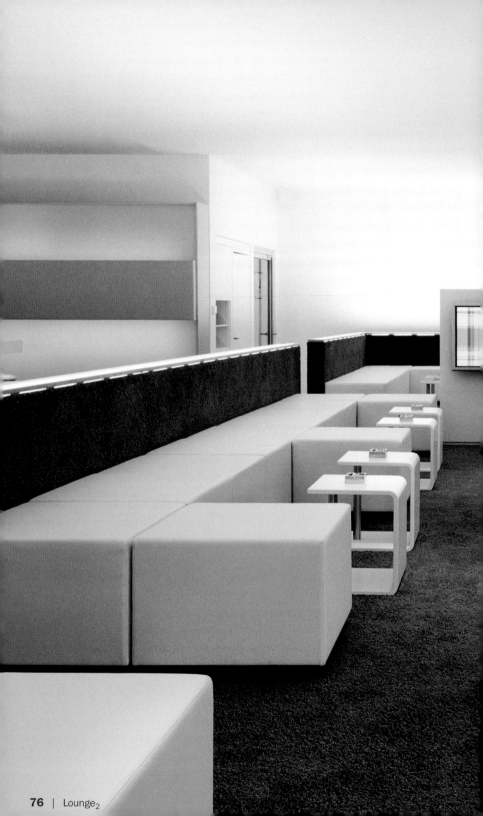

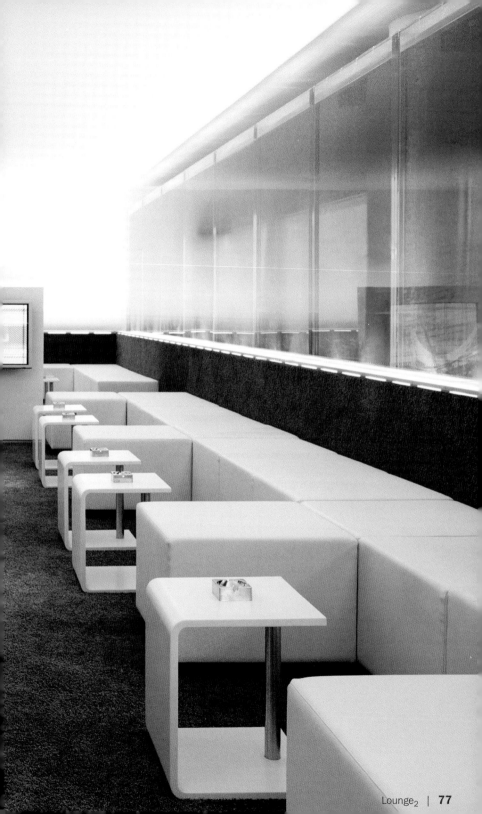

Monkey Room

Design: Sabine Löwenhauser | Chef: Lars Stadlbauer, Andreas Rudnik

Amalienstraße 38 | 80799 München | Schwabing
Phone: +49 89 28 80 60 29
www.monkeyroom.de | info@monkey-room.de
Subway: Universität
Opening hours: Mon–Thu 11 am to 2 am, Fri 11 am to 3 am, Sat 6 pm to 3 am
Average price: € 25
Cuisine: Contemporary
Special features: Reservation recommended, scene hangout

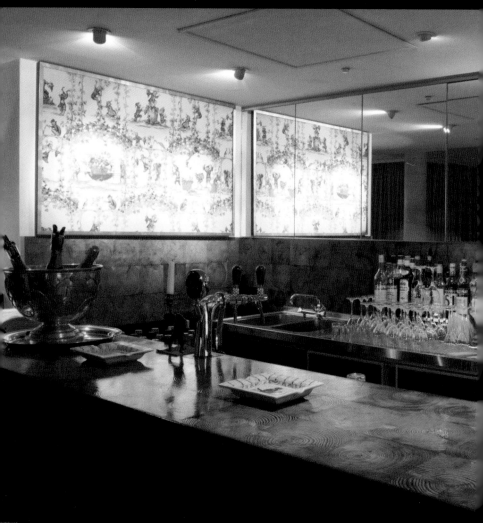

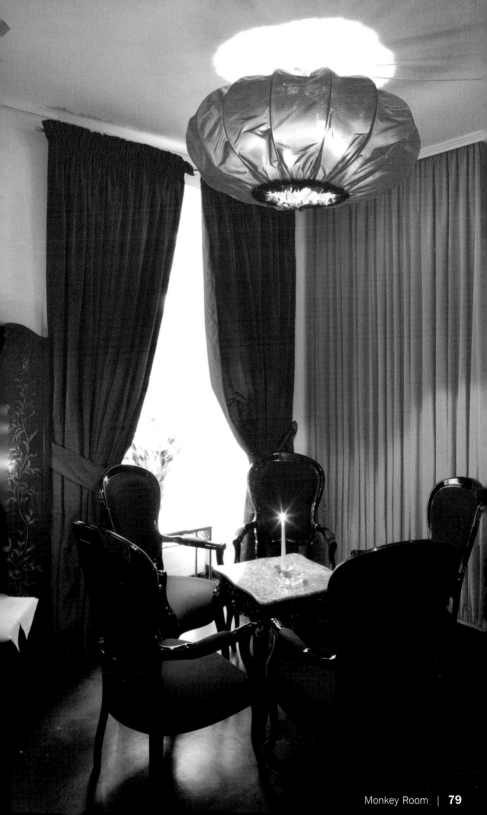

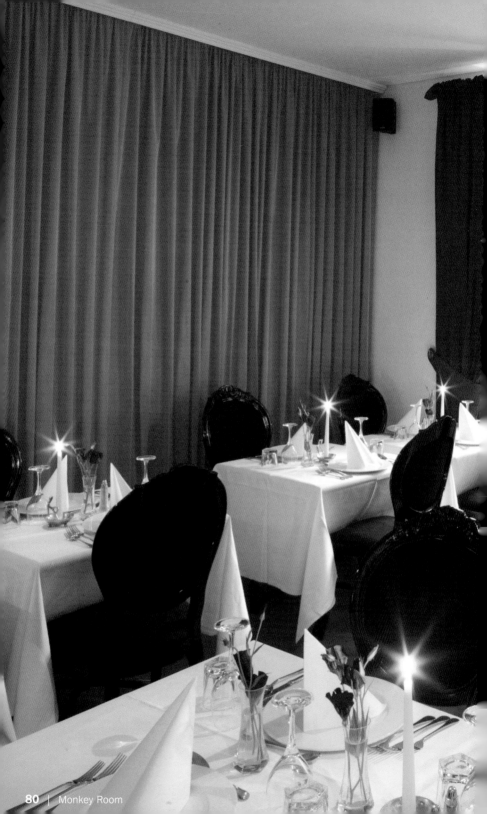

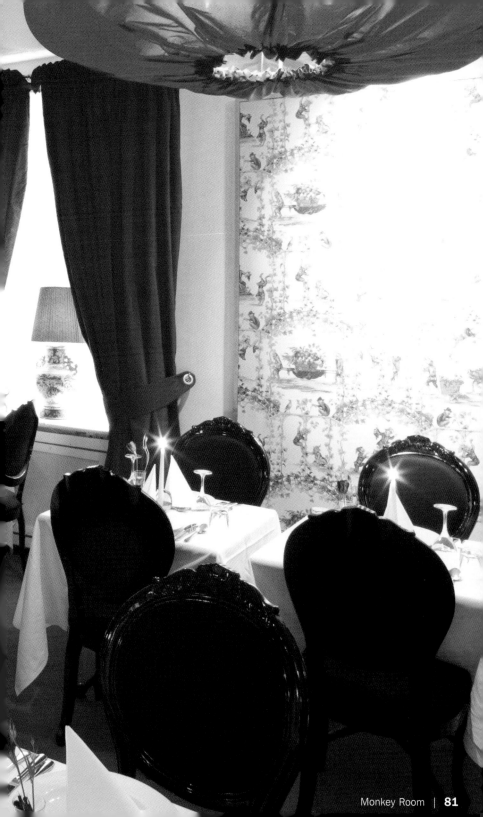

Filetsteak mit Gamba

an glasiertem Gemüse und Rosmarinkartoffeln

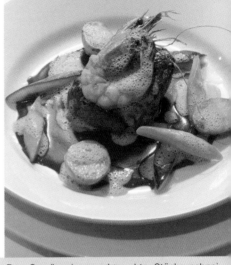

Sirloin Steak with Gambas, glazed Vegetables and Rosemary Potatoes

Filet de bœuf aux gambas, légumes glacés et pommes de terre au romarin

Solomillo con gamba y verdura glaseada y patatas al romero

Bistecca di filetto con gamberoni accompagnata da verdura glassata e patate al rosmarino

10 kleine Kartoffeln; 3 EL Olivenöl; 1 Knoblauchzehe; 1 Zweig Rosmarin; Salz, Pfeffer
8 große Garnelen mit Kopf; 1 Bund Suppengrün, gewürfelt; 10 g Ingwer; 1 Stange Zitronengras; 1 Knoblauchzehe; Tomatenmark; 2 cl Weinbrand; 500 ml Gemüsebrühe; 200 ml Sahne
1 Zucchini; 1 Karotte; 1 Aubergine; Butter; 100 ml Gemüsebrühe
4 Rinderfiletsteaks à 180 g; 2 EL Olivenöl; Salz, Pfeffer

Die Kartoffeln waschen, halbieren und mit Olivenöl, Knoblauch, Rosmarin, Salz und Pfeffer im Ofen bei 180 °C ca. 30 Minuten garen.
Die Garnelen von Kopf und Panzer befreien. Kopf und Panzer mit dem Suppengrün, Ingwer, Zitronengras und Knoblauch anschwitzen. Das Tomatenmark hinzufügen und leicht anbraten. Mit dem Weinbrand ablöschen und flambieren. Gemüsebrühe und Sahne angießen und eine halbe Stunde kochen lassen.

Das Gemüse in mundgerechte Stücke schneiden. Die Karotten ca. 5 Minuten blanchieren und abschrecken. Die Rinderfilets salzen und pfeffern, bei starker Hitze von allen Seiten anbraten und im Ofen bei ca. 80 °C ca. 10 Minuten ziehen lassen.
Das gesamte Gemüse in einen Topf geben und mit Gemüsebrühe und Butter bedecken. Bei starker Hitze kochen lassen bis die Gemüsebrühe reduziert und das Gemüse glasiert ist. Die Rahmsoße durch ein Sieb passieren und nach Belieben mit einer Mehlschwitze abbinden.
Die Rahmsauce mit einem Zauberstab schaumig mixen. Rinderfilet, Garnelen, Gemüse und Kartoffeln auf vier Tellern anrichten und mit dem Schaum begießen.

10 small potatoes; 3 tbsp olive oil; 1 clove garlic; 1 twig rosemary; salt, pepper
8 large gambas; 1 soup greens, diced; 1/3 oz ginger; 1 stalk lemon gras; 1 clove garlic; Tomato paste; 2 cl brandy; 500 ml vegetable stock; 200 ml cream
1 zucchini; 1 carrot; 1 eggplant; butter; 100 ml vegetable stock
4 sirloin steaks, 6 1/2 oz each; 2 tbsp olive oil; salt, pepper

Clean and cut potatoes in half and bake in a 360 °F oven with olive oil, garlic, rosemary, salt and pepper for 30 minutes.
Remove head and shell from the gambas. Braise heads and shells with soup greens, ginger, garlic and lemon gras. Add tomato paste and roast quickly. Fill up with brandy and flambé. Add vegetable stock and cream and let simmer for 30 minutes.

Cut the vegetables in bite-size pieces. Blanch the carrots for 5 minutes, then ringe with cold water. Season the sirloin filets with salt and pepper and fry from all sides in very hot oil. Take out and place in a 180 °F oven for 10 minutes.
Put all vegetables in a pot, cover with vegetable stock and butter. Cook at high temperature until the liquid is dissolved and vegetables are glazed. Pour the cream sauce through a strainer and thicken with a roux, if necessary.
Mix the sauce in a blender. Place sirloin filets, gambas, vegetables and potatoes on four plates and finish with cream sauce.

10 petites pommes de terre ; 3 c. à soupe d'huile d'olive ; 1 gousse d'ail ; 1 brin de romarin ; sel, poivre 8 gambas avec leur tête ; herbes potagères en dés ; 10 g de gingembre ; 1 brin de citronnelle ; 1 gousse d'ail ; Concentré de tomates ; 2 cl d'eau-de-vie ; 500 ml de bouillon de légumes ; 200 ml de crème 1 courgette ; 1 carotte ; 1 aubergine ; beurre ; 100 ml de bouillon de légumes 4 filets de bœuf à 180 g ; 2 c. à soupe d'huile d'olive ; sel, poivre

Laver les pommes de terre, les couper en deux, les garnir d'huile d'olive, d'ail, de romarin, de sel et de poivre et les cuire au four à 180 °C environ 30 minutes.
Enlever la tête et la carapace des gambas. Faire revenir la tête et la carapace avec les herbes potagères, le gingembre, la citronnelle et l'ail. Ajouter le concentré de tomates et faire revenir légèrement.

Mouiller avec l'eau-de-vie et flamber. Verser le bouillon de légumes et la crème et laisser cuire une demi-heure.
Couper les légumes en petites bouchées. Blanchir la carotte environ 5 minutes et les rafraîchir. Saler et poivrer les filets de bœuf et les faire revenir à feu vif de tous les côtés. Les enfourner à environ 80 °C pendant environ 10 minutes.
Mettre tous les légumes dans une casserole et les recouvrir avec le bouillon de légumes et le beurre. Faire cuire à feu vif jusqu'à ce que le bouillon de légumes soit réduit et que les légumes soient glacés. Passer au tamis la sauce à la crème et lier avec un roux à votre convenance.
Faire mousser la sauce à la crème à l'aide d'un mixeur plongeant. Dresser les filets de bœuf, les gambas, les légumes et les pommes de terre sur quatres assiettes et les garnir de mousse.

10 patatas pequeñas; 3 cucharadas de aceite de oliva; 1 diente de ajo; 1 rama de romero; sal, pimienta
8 gambas grandes con cabeza; 1 manojo de verdura para el caldo, a cuadritos; 10 g de jengibre; 1 palo de hierba de limón; 1 diente de ajo; tomate concentrado; 2 cl de brandy; 500 ml de caldo de verdura; 200 ml de nata
1 calabacín; 1 zanahoria; 1 berenjena; mantequilla; 100 ml de caldo de verdura
4 solomillos de buey de 180 g cada uno; 2 cucharadas de aceite de oliva; sal, pimienta

Lavar las patatas, cortarlas por la mitad y cocerlas al horno a 180 °C durante 30 minutos aprox. con aceite de oliva, ajo, romero, sal y pimienta.
Quitar la cabeza y el caparazón a las gambas. Dorar las cabezas y los caparazones con las hierbas para el caldo, el jengibre, la hierba de limón y el ajo. Añadir el tomate concentrado y freír ligeramente. Rebajar y flambear con el brandy.

Echar el caldo de verdura y la nata y dejar hervir una media hora.
Cortar la verdura a trozos pequeños. Escalfar la zanahoria 5 minutos aprox. y pasar por agua fría.
Echar sal y pimienta a los solomillos de buey y freírlos por todos los lados a fuego fuerte y dejar reposar en el horno a 80 °C aprox. durante 10 minutos más o menos.
Poner toda la verdura en una olla y tapar con el caldo de verdura y la mantequilla. Dejar hervir a fuego fuerte hasta que rebaje el caldo de verdura y la verdura esté glaseada. Tamizar la salsa de nata por un colador y espesar al gusto con harina para freír.
Batir la salsa de nata con un miniprimer hasta espumar. Colocar los filetes de solomillo de buey, las gambas, la verdura y las patatas en cuatro platos y regar con la espuma.

10 patate piccole; 3 cucchiai di olio d'oliva; 1 spicchio d'aglio; 1 rametto di rosmarino; sale, pepe
8 gamberoni con la testa; 1 mazzetto di odori per minestra tagliati a dadini; 10 g di zenzero; 1 gambo di erba limone; 1 spicchio d'aglio; concentrato di pomodoro; 2 cl di brandy; 500 ml di brodo vegetale; 200 ml di panna
1 zucchina; 1 carota; 1 melanzana; burro; 100 ml di brodo vegetale
4 bistecche di filetto di manzo da 180 g; 2 cucchiai di olio d'oliva; sale, pepe

Lavate le patate, dividetele a metà e fatele cuocere con l'olio d'oliva, l'aglio, il rosmarino, il sale e il pepe in forno per ca. 30 minuti a 180 °C.
Private i gamberoni della testa e corazza. Fate dorare le teste e le corazze con gli odori, lo zenzero, l'erba limone e l'aglio. Aggiungete il concentrato di pomodoro e fate rosolare leggermente.

Versatevi il brandy e flambate. Versate il brodo vegetale e la panna e lasciate cuocere mezz'ora.
Tagliate la verdura a bocconcini. Sbollentate la carota per ca. 5 minuti e raffreddatele in acqua.
Salate e pepate i filetti di manzo, fateli rosolare a fuoco vivo da tutti i lati e lasciateli cuocere in forno per ca. 10 minuti a ca. 80 °C.
Mettete tutta la verdura in un tegame e copritela di brodo vegetale e burro. Fate cuocere a fuoco vivo finché il brodo vegetale sarà ridotto e la verdura glassata. Passate la salsa alla panna in un colino e fatela legare a piacere con soffritto di farina.
Montate la salsa alla panna con un frullatore ad immersione fino ad ottenere una spuma. Mettete il filetto di manzo, i gamberoni, la verdura e le patate su quattro piatti e bagnate con un po' di spuma.

www.nageundsauge.de | nage.sauge@t-online.de
Subway: Isartor
Opening hours: Every day 5 pm to 1 am
Average price: € 9
Cuisine: Italian, focaccia bar
Special features: DJ's on Saturday

Ente Elvis

Duck Elvis

Canard Elvis

Pato Elvis

Anatra Elvis

4 Flugentenbrustfilets
1 Apfel, in Scheiben
16 Pflaumen, geviertelt
1 Zucchini, in Scheiben
100 g Champignons, in Scheiben
3 cl Cassis-Likör
300 g Blattsalate
(z.B. Romana, Eichblatt, Ruccola)
3 EL Cranberry-Saft
2 EL Olivenöl
2 EL Balsamico-Essig
Salz, Pfeffer
2 Tomaten, geachtelt
8 Gurkensticks
2 Karotten, in Schnitzen
Peperoni und Oliven
8 Scheiben Focaccia (Ital. Fladenbrot)

Flugentenbrustfilets auf beiden Seiten anbraten und in Scheiben schneiden.
Apfelscheiben, Pflaumen, Zucchinischeiben und Champigonscheiben in Olivenöl glasig anbraten, würzen und mit Cassis-Likör ablöschen. Die Entenscheiben darunter heben. Vinaigrette aus Cranberry-Saft, Öl, Balsamico-Essig, Salz und Pfeffer bereiten. Salat mit Cranberry-Vinaigrette anmachen, Gebratenes darauf anrichten und mit Tomaten, Gurkensticks, Karottensticks, Peperoni und Oliven dekorieren. Dazu passt italienisches Fladenbrot.

4 duckbreast filets
1 apple, sliced
16 plums, in quarters
1 zucchini, sliced
3 1/2 oz mushrooms, sliced
3 cl Cassis liqueur
10 1/2 oz mixed lettuce
(e.g. Romana, Oak Leaf letture, Rucola)
3 tbsp Cranberry juice
2 tbsp olive oil
2 tbsp balsamic vinegar
Salt, pepper
2 tomatoes, sliced
8 gherkin sticks
2 carrots, in sticks
Jalapeno peppers and olives
8 slices Focaccia (Italian bread)

Fry duck breasts on both sides and cut into slices.
Sauté apple, plums, zucchini and mushrooms in olive oil, season and add cassis liqueur. Carefully mix with duck breast. Make a vinaigrette with cranberry juice, olive oil, balsamic vinegar, salt and pepper. Marinade lettuce with vinaigrette, place fried toppings on lettuce and decorate with tomatoes, gherkins, carrots, jalapeno-peppers and olives. Serve Focaccia with it.

4 magrets de canard
1 pomme en rondelles
16 pruneaux coupés en quatre
1 courgette en rondelles
100 g de champignons en lamelles
3 cl de liqueur de cassis
300 g de laitue
(p. ex. romaine, feuille de chêne, roquette)
3 c. à soupe de jus de cranberry
2 c. à soupe d'huile d'olive
2 c. à soupe de vinaigre balsamique
Sel, poivre
2 tomates coupées en huit
8 bâtonnets de concombre
2 carottes, en bâtonnets
Piments et olives
8 tranches de focaccia (pain italien)

Faire cuire les magrets de filet des deux côtés et les couper en tranches.
Faire revenir la pomme, les pruneaux, la courgette et les champignons dans l'huile d'olive, épicer et mouiller avec la liqueur de cassis. Ajouter les magrets de canard. Préparer la vinaigrette composée de jus de cranberry, d'huile, de vinaigre balsamique, de sel et de poivre. Mélanger la vinaigrette à la salade, dresser le tout sur la salade et décorer avec les tomates, les concombres, les carottes, les piments et les olives. Servir avec la focaccia.

4 filetes de pechuga de pato volador
1 manzana, a rodajas
16 ciruelas, a cuartos
1 calabacín, a rodazas
100 g de champiñones, a rodajas
3 cl de licor de cassis
300 g de lechugas
(z.B. romana, eichblatt, rúcola)
3 cucharadas de zumo de arándanos encarnados
2 cucharadas de aceite de oliva
2 cucharadas de vinagre Balsámico
Sal, pimienta
2 tomates cortados a octavos
8 palitos de pepinillos
2 zanahorias, a pedazos
Peperoni y olivas
8 rodajas de focaccio (pan italiano de especias)

Freír los filetes de pechugas de pato por ambos lados y cortarlos a rodajas.
Sofreír en aceite de oliva las rodajas de manzana, las ciruelas, las rodajas de calabacín y las rodajas de champiñones, aliñar y rebajar con el licor de cassis. Colocar debajo las rodajas de pato. Preparar una vinagreta con el zumo de arándanos encarnados, el aceite, el vinagre Balsámico, la sal y la pimienta. Aliñar la ensalada con la vinagreta de arándanos encarnados. Colocar encima el frito y decorar con los tomates, los palitos de pepinillo, los palitos de zanahoria, los peperoni y las olivas. Con ello combina el pan italiano de especias.

4 filetti di petto di anatra muta
1 mela a fette
16 prugne divise in quattro
1 zucchina a fette
100 g di champignon a fette
3 cl di liquore di cassis
300 g di insalata verde
(ad es. romana, foglia di quercia, rucola)
3 cucchiai di succo di mirtillo rosso
2 cucchiai di olio d'oliva
2 cucchiai di aceto balsamico
Sale, pepe
2 pomodori divisi in otto parti
8 bastoncini di cetrioli
2 carote a bastoncini
Peperoncini sott'aceto e olive
8 fette di focaccia

Fate rosolare i filetti di petto di anatra muta su ogni lato e tagliateli a fette.
Fate rosolare le fette di mela, le prugne, le fette di zucchina e di champignon nell'olio d'oliva fino a farle diventare trasparenti, condite e versatevi il liquore di cassis. Unitevi le fette di anatra. Preparate una vinaigrette con succo di mirtillo rosso, olio, aceto balsamico, sale e pepe. Condite l'insalata con la vinaigrette al mirtillo rosso, mettetevi sopra l'anatra fritta e decorate con pomodori, bastoncini di cetrioli, bastoncini di carote, peperoncini sott'aceto e olive. Accompagnate con focaccia.

Nektar

Design: Patrick Ferrier | Chef: Markus Huschka

Stubenvollstraße 1 | 81667 München | Haidhausen
Phone: +49 89 45 91 13 11
www.nektar.de | reservierung@nektar.de
Subway: Rosenheimer Platz, Gasteig
Opening hours: Every day 7 pm to 1 am
Average price: € 40
Cuisine: Contemporary
Special features: Reservation recommended, celeb hangout, restaurant-lounge

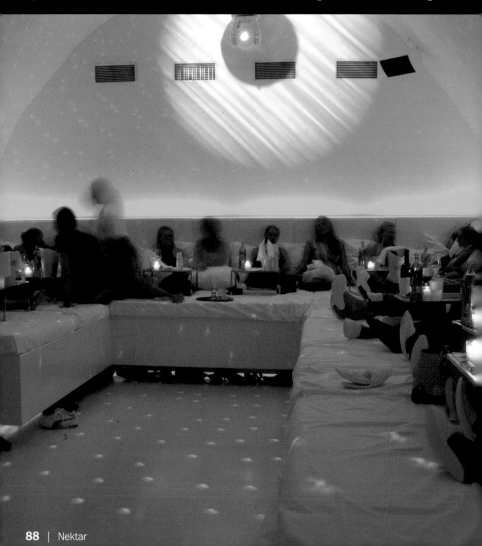

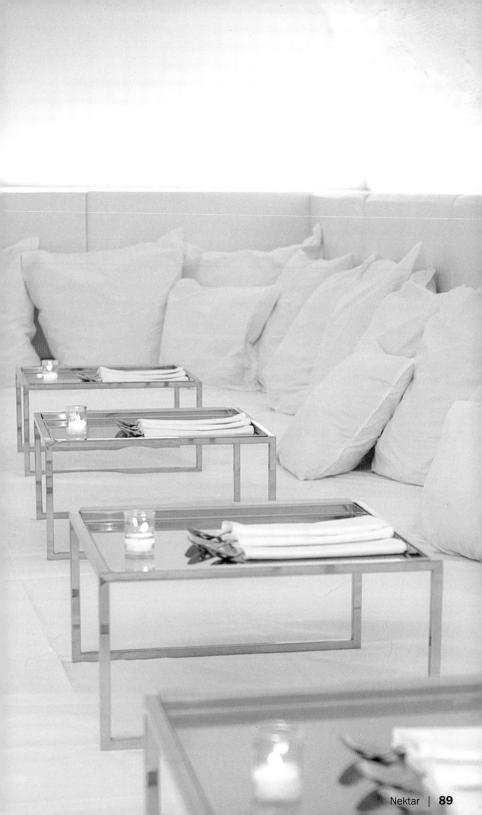

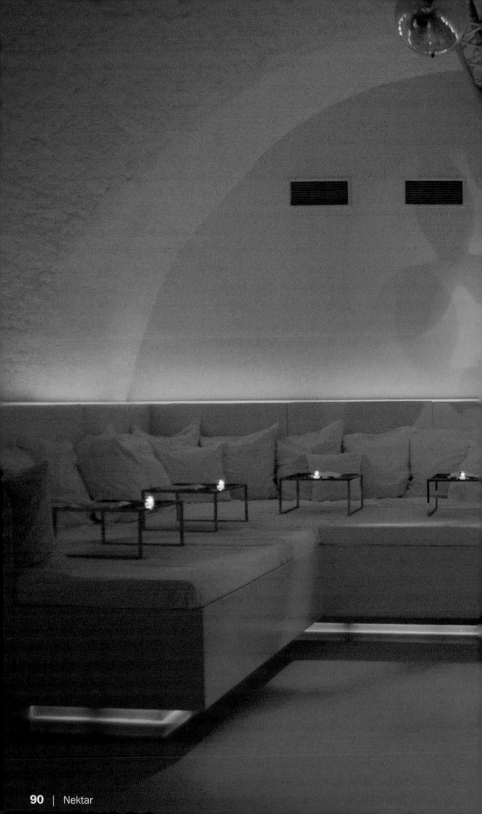

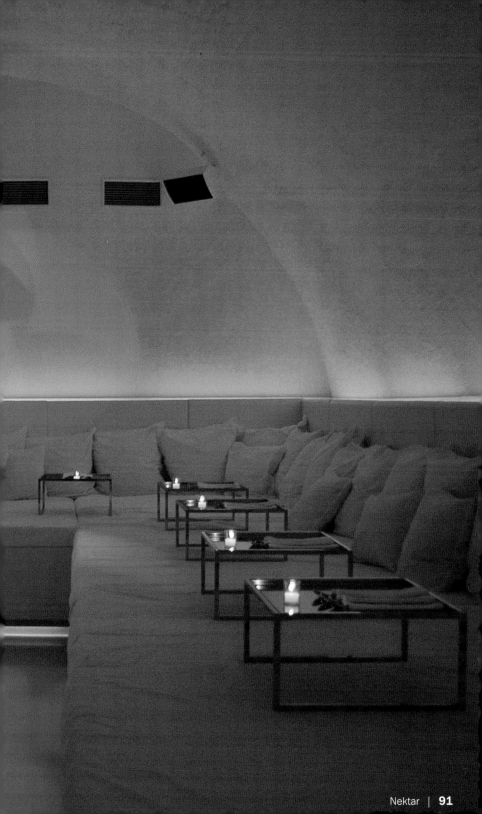

Rumfordstraße 34 | 80469 München | Ludwigsvorstadt-Isarvorstadt
Phone: +49 89 21 01 90 60
www.nero-muenchen.de | kontakt@nero-muenchen.de
Subway: Isartor, Marienplatz
Opening hours: Every day 6 pm to 3 am
Cuisine: Italian
Special features: Pizza spot for creative people

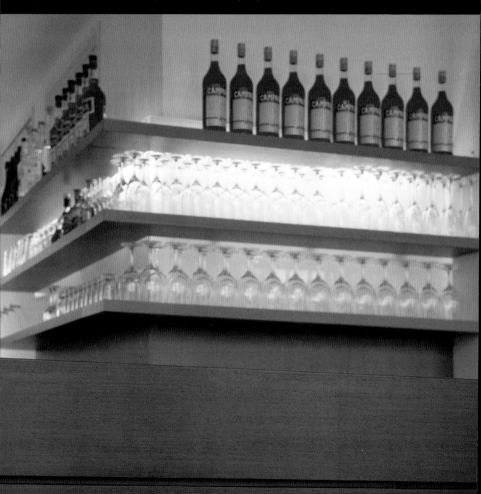

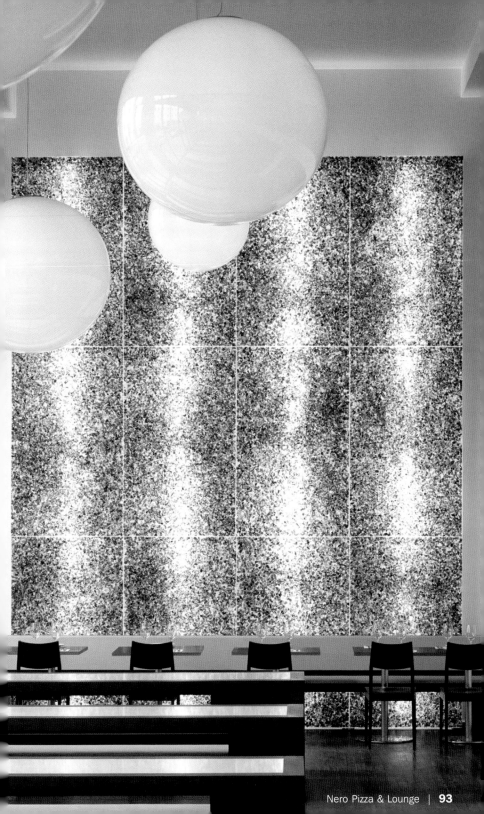

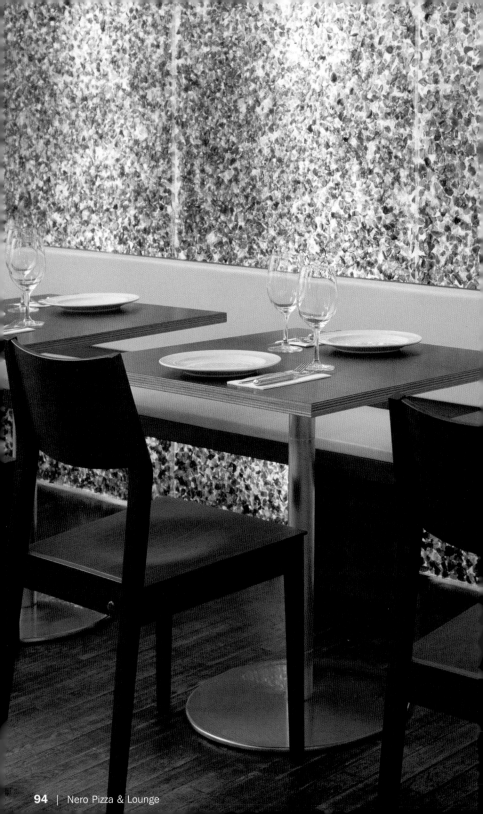

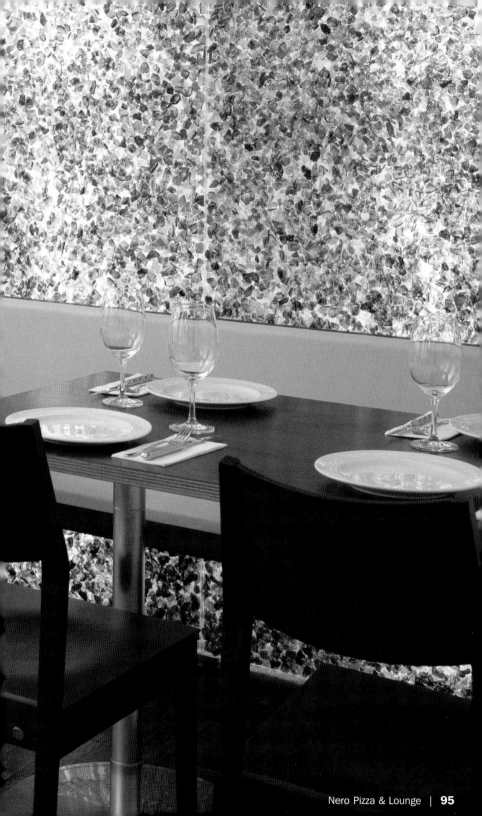

Pur Pur oriental bar & restaurant

Chef: Manfred Welcher

Dreimühlenstraße 30 | 80469 München | Ludwigsvorstadt-Isarvorstadt
Phone: +49 89 74 74 74 57
www.pur-pur-bar.de | info@pur-pur-bar.de
Subway: Sendlinger Tor
Opening hours: Sun–Thu 5 pm to 1 am, Fri–Sat 5 pm to 2 am
Average price: € 15
Cuisine: Modern Oriental
Special features: Reservation recommended, late night dining, group dining

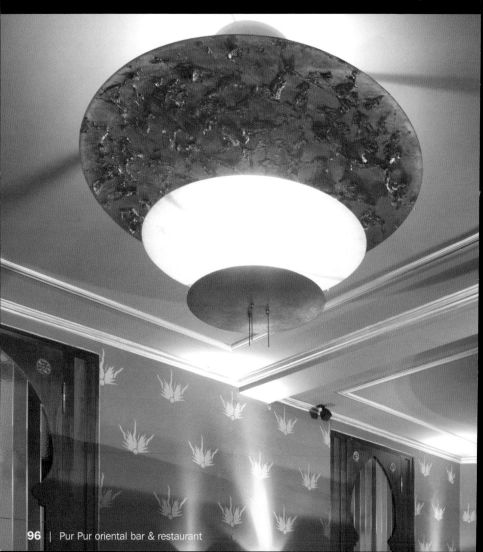

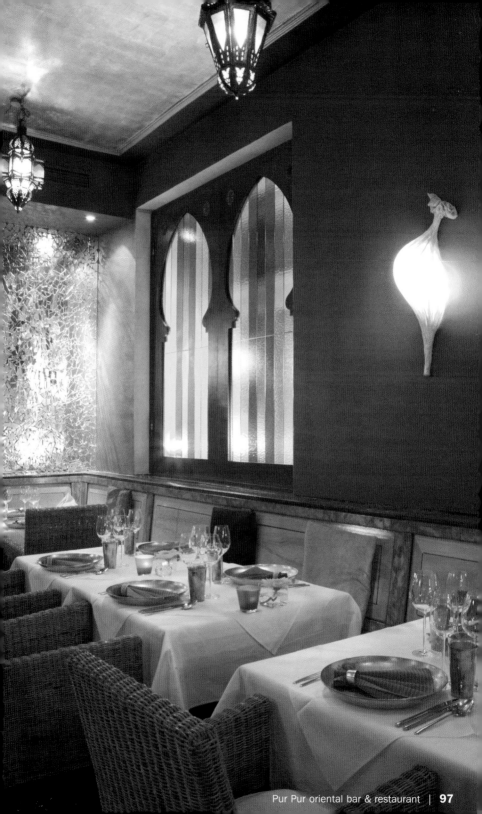

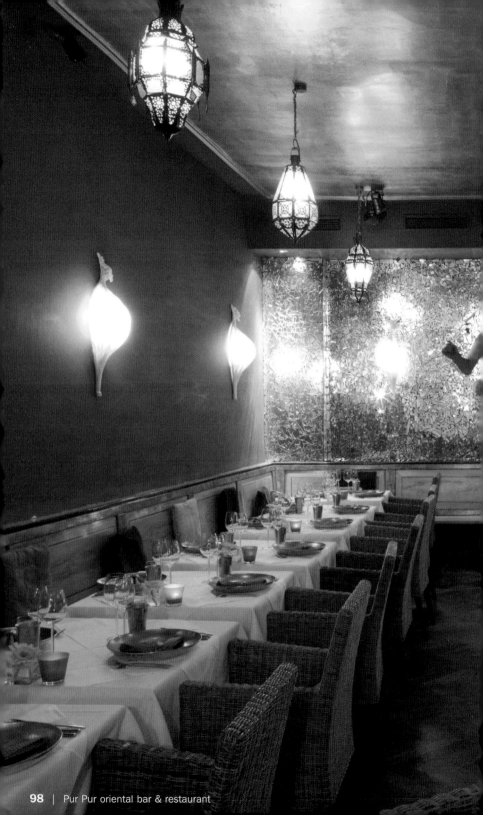

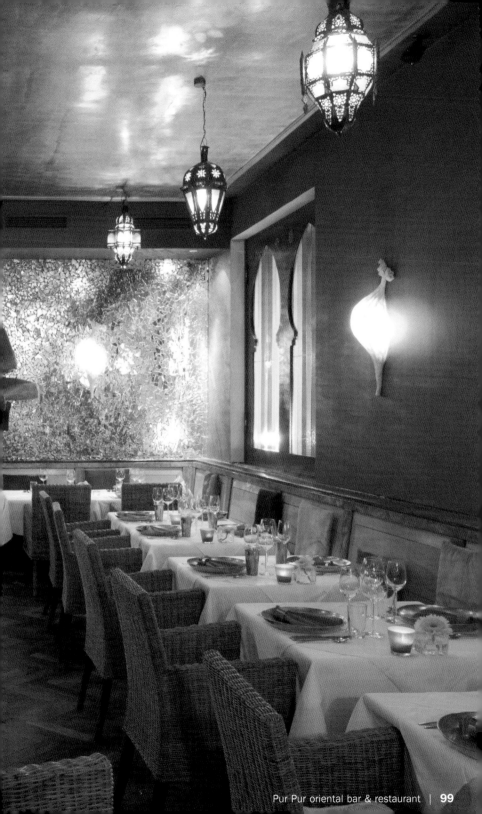

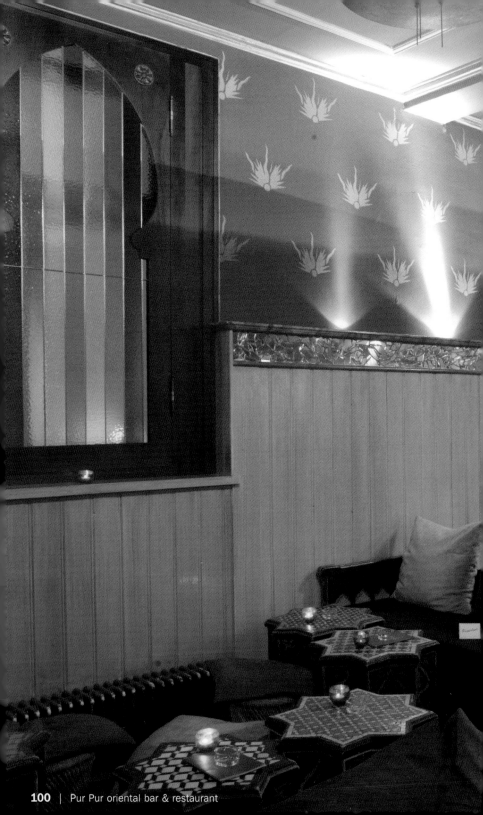

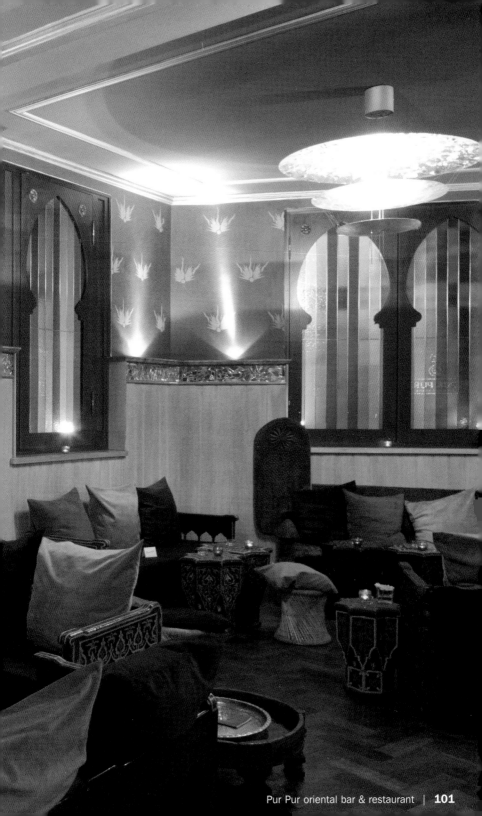

Schumann's Bar am Hofgarten

Design: Boesel Benkert Hohberg Architekten
Chef: Charles Schumann

Odeonsplatz 6–7 | 80539 München | Altstadt
Phone: +49 89 22 90 60
www.schumanns.de | info@schumanns.de
Subway: Odeonsplatz
Opening hours: Mon–Fri 9 am to 3 am, lunch 12 noon to 3 pm, Sat–Sun 6 pm to 3 am
Average price, beverage: € 7,50; Average price, food: € 10,50
Cuisine: International
Special features: Reservation recommended, celeb hangout, Gault Millau prized

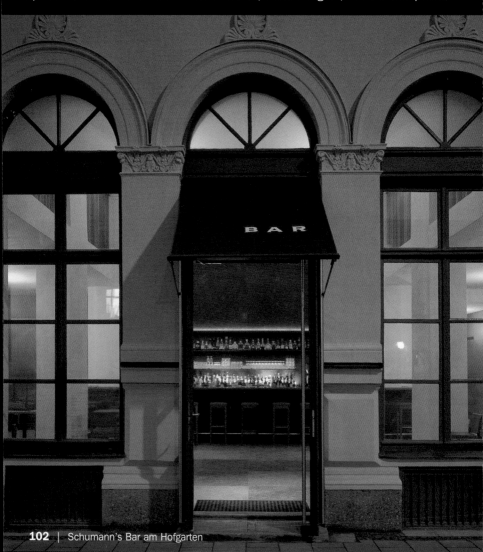

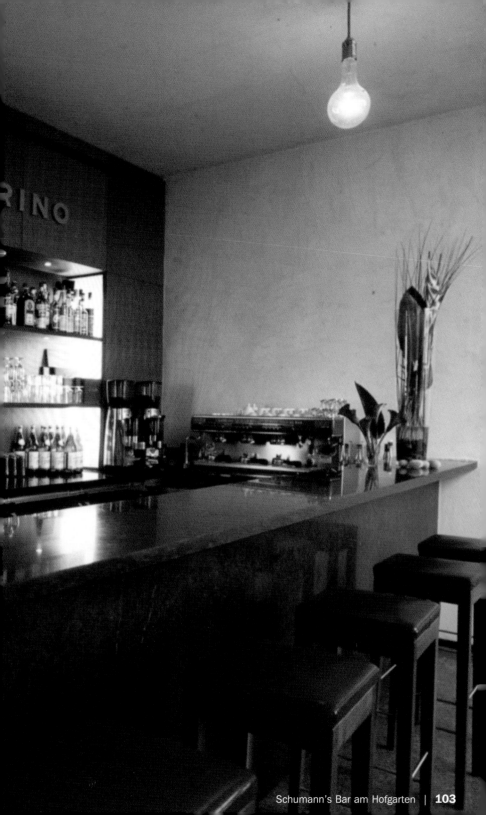

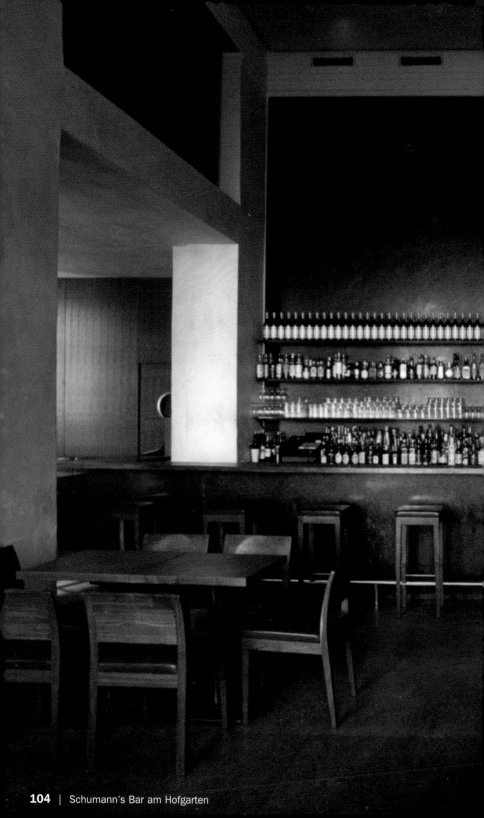

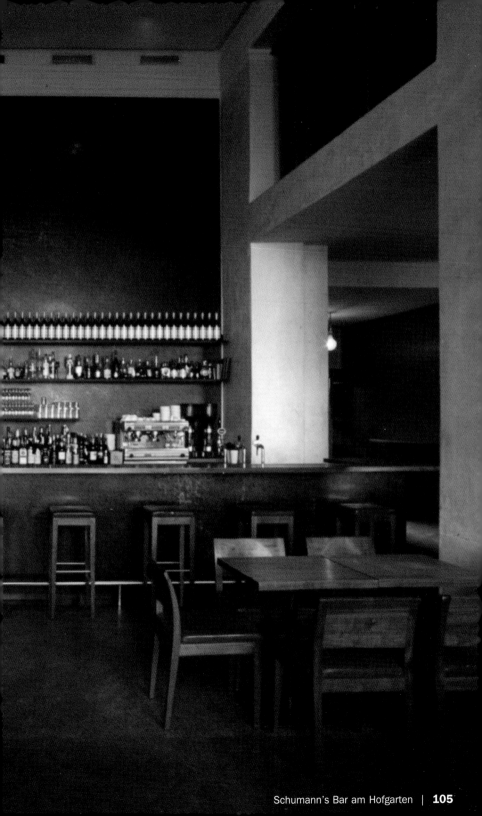

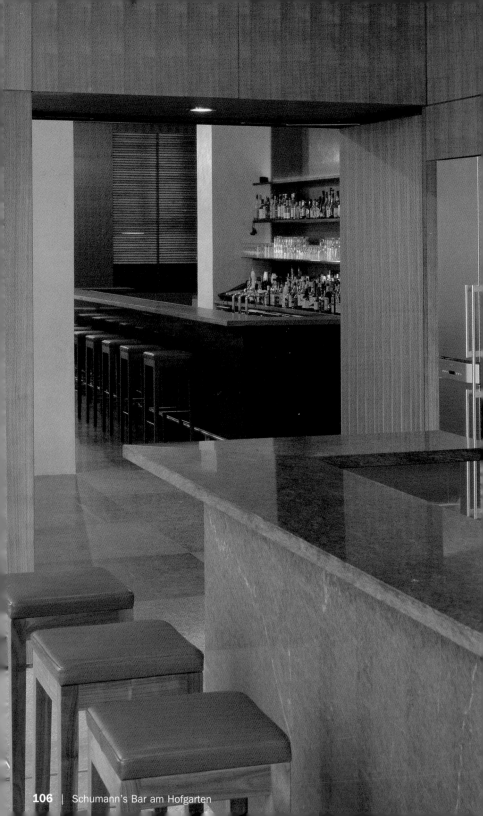

Camparino *2004

4 Tropfen Angosturabitter
3 Tropfen Vanill Zucca (Vanillelikör)
2 cl Martini Dry
2 cl Campari
Champagner
1/2 Vanillestange (1 x der Länge nach durchge-
schnitten)
Zitronenzeste
Eiswürfel

In einem Cocktailshaker Angosturabitter, Vanill
Zucca, Martini Dry und Campari mixen und
in ein Whiskyglas mit Eiswürfeln geben. Mit
Champagner auffüllen und mit der Vanillestange
und der Zitronenzeste garnieren.

4 drops of Angosturabitter
3 drops of Vanill Zucca (Vanillaliqueur)
2 cl Martini Dry
2 cl Campari
Champagne
1/2 vanilla bean (cut once lengthwise)
Lemon zest
Ice cubes

Mix Angosturabitter, Vanill Zucca, Martini Dry
and Campari in a cocktail shaker and pour in a
Whiskyglas with ice cubes. Fill up with champagne
and garnish with vanilla bean and lemon zest.

4 gouttes d'angostura bitter
3 gouttes de vanill zucca (liqueur de vanille)
2 cl de martini dry
2 cl de campari
Champagne
1/2 bâton de vanille (fendu 1 X dans le sens de
la longueur)
Zeste de citron
Glaçons

Mélanger dans un shaker l'angostura bitter, la
vanill zucca, le martini dry et le campari et verser
le tout dans un verre à whisky avec des glaçons.
Remplir de champagne et garnir avec le bâton de
vanille et le zeste de citron.

4 gotas de licor de Angostura Bitter
3 gotas de Vanill Zucca (licor de vainilla)
2 cl de Martini Dry
2 cl de Campari
Champán
1/2 palo de vainilla (cortado una vez a lo largo)
Ceste de limón
Cubitos de hielo

Mezclar en una coctelera el licor de Angosturabitter,
el Vanill Zucca, el Martini Dry y el Campari y echar
en un vaso de whisky con cubitos de hielo.
Completar con el champán y adornar con el palo
de vainilla y el ceste de limón.

4 gocce di amaro angostura
3 gocce di Vanill Zucca (liquore alla vaniglia)
2 cl di Martini Dry
2 cl di Campari
Champagne
1/2 stecca di vaniglia (tagliata 1 volta nel senso
della lunghezza)
Scorza di limone
Cubetti di ghiaccio

In uno shaker mescolate l'amaro angostura, il
Vanill Zucca, il Martini Dry e il Campari e versate
il tutto in un bicchiere da whisky con cubetti di
ghiaccio. Colmate con lo champagne e guarnite
con la stecca di vaniglia e la scorza di limone.

Schwarz & Weiz

Design: Klein Haller k/h büro für innenarchitektur und design
Chef: Sascha Baum

Bayerstraße 12 | 80335 München | Ludwigsvorstadt-Isarvorstadt
Phone: +49 89 59 94 80
www.dorint.de | info.mucbay@dorint.com
Subway: Hauptbahnhof
Opening hours: Every day 9 am to 11 am, 6 pm to 12 midnight
Average price: € 35
Cuisine: International
Special features: Reservation recommended, Bar scene, celeb hangout, private rooms

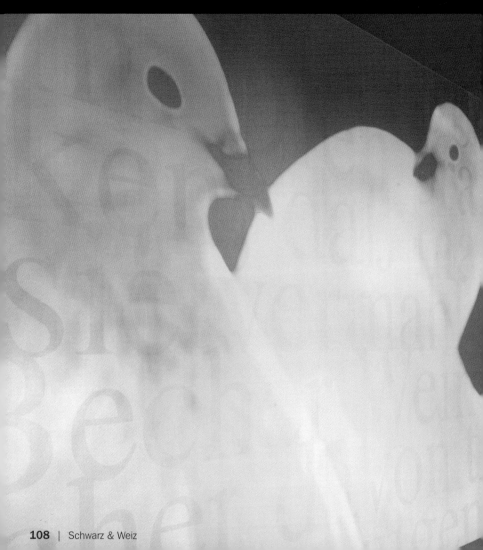

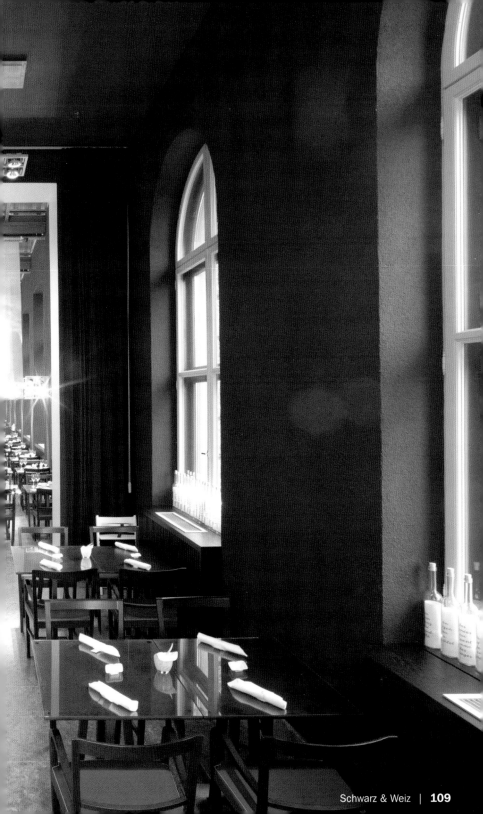

Nimm eine
Turteltaube
und laß sie
im Ofen
braten, bis
daß sie so
trocken, daß
man zu
Staub sie
vermahlen
kann.
In einem
Becher
Wein
gereicht
wird der,
welcher
davon trinkt,
Dir bald
in Liebe
zugeneigt.

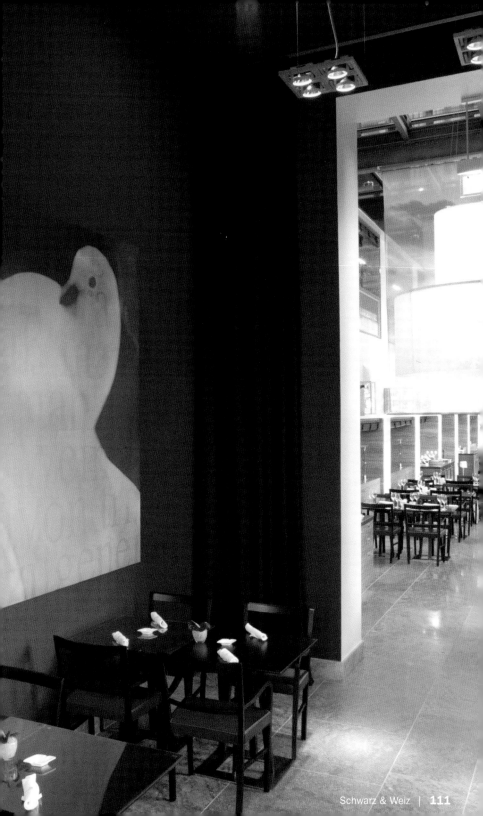

Willy Brandt Platz 5 | 81929 München | Riem
Phone: +49 89 74 74 74 78
www.soops.de | info@soops.de
Subway: Messestadt West
Opening hours: Mon–Fri 8 am to 8 pm, Sat 9 am to 8 pm, Sun closed
Average price: € 6
Cuisine: Fresh and easy

Sushi + Soul

Design: Jean-Christophe Durussel | Chef: Masahiro Kato

Klenzestraße 71 | 80469 München | Ludwigsvorstadt-Isarvorstadt
Phone: +49 89 2 01 09 92
www.sushi-soul.de | info@sushi-soul.de
Subway: Fraunhoferstraße
Opening hours: Every day 5 pm to 1 am, Sat 5 pm to 2 am
Average price: € 15
Cuisine: Japanese
Special features: Long communicative tables, private rooms

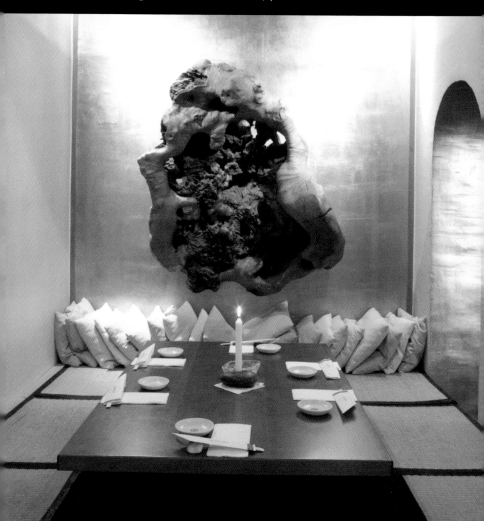

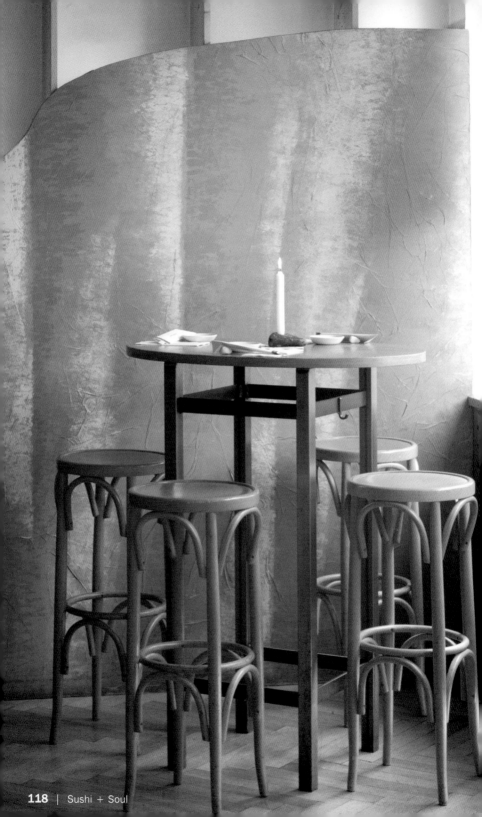

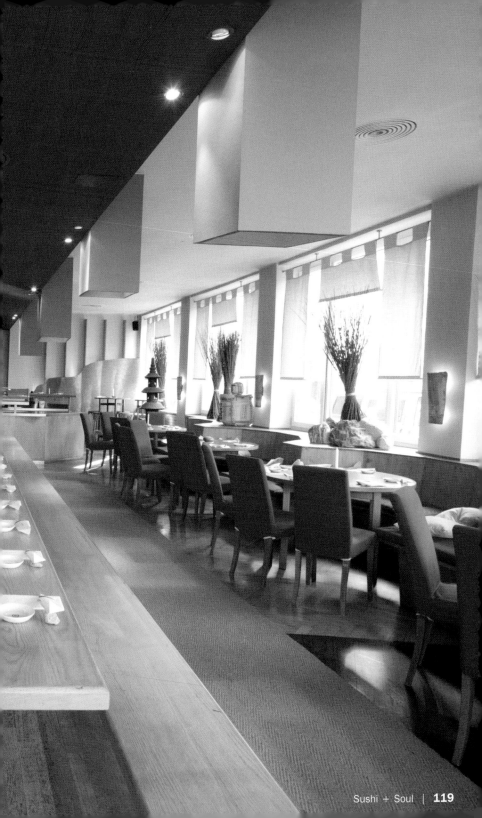

Verschiedene Sushi-Arten

Different Varieties of Sushi

Différents types de sushi

Diferentes clases de sushi

Diversi tipi di sushi

Japanischer Sushi-Reis: 1 kg Reis; 30 g Salz; 60 g Zucker; 120 ml Reisessig

Für verschiedene Sushi-Arten: Nori (Seetangblätter); Wasabi (jap. Meerrettich); 1 Salatgurke oder 150 g roher Lachs; Surimi (Krabbenfleisch); 1 Avocado; Geröstete Sesamsamen; Thunfisch (Sushi-Qualität); Weißfisch; Garnelen, gekocht; Sojasauce, Wasabi und eingelegter Ingwer als Dip

Den Reis 20 Minuten kochen, abkühlen lassen und mit Salz, Zucker und Reis-Essig mischen.

Makisushi: Den Sushi-Reis ca. 1/2 cm dick auf einem Nori-Blatt verteilen, mit etwas Wasabi bestreichen und in die Mitte die Gurke in Streifen oder den Lachs legen. Mit Hilfe einer Bambusmatte zu einer Rolle formen und in sechs Stücke schneiden.

Inside-Out-Rolle (Californiamaki): Eine Handvoll Sushi-Reis gleichmäßig auf ein Blatt Nori verteilen, das Blatt umdrehen, einen Streifen Wasabi darauf geben und mit Surimi und Avocadostreifen belegen. Mit Hilfe einer Bambusmatte einen Quader formen, mit einer oder mehreren Seiten in gerösteten Sesam tunken und in sechs Stücke schneiden.

Nigirisushi: Rohen Lachs, Thunfisch und Weißfisch in rechteckige Stücke schneiden und gekochte Garnelen der Länge nach aufschneiden. Ca. 2 EL Sushi-Reis in die Hand nehmen und mit leichtem Druck zu einem etwas größeren Block formen, etwas Wasabi auf die Oberseite geben und mit dem Fisch bzw. Garnelen belegen.

Serviert wird das Sushi mit Sojasauce, Wasabi und eingelegtem Ingwer.

Japanese sushi-rice: 2 pounds rice; 1 oz salt; 2 oz sugar; 120 ml rice vinegar

For different sushi: nori (seaweed leaves); wasabi (Japanese horseradish); 1 cucumber or 5 oz raw salmon; surimi (crab meat); 1 avocado; roasted sesame seeds; tuna (sushi-quality); whitefish; king prawns, cooked; soy sauce, wasabi and pickled ginger for dipping

Cook rice for 20 minutes, chill and mix with salt, sugar and rice vinegar.

Makisushi: Put sushi-rice approx. 1/2 cm on a nori leaf, spread some wasabi on the rice and place a cucumber in stripes or salmon in the middle of the leaf. Use a bamboo mat to shape into a tight roll. Cut into six pieces.

Inside-Out-Roll (Californiamaki): Put one handful of sushi-rice on a leaf of nori, turn leaf around, place a strip of wasabi in the middle and fill with surimi and avocado slices. Use a bamboo mat to shape into a cuboid and dip one or more sides into roasted sesame seeds. Cut into six pieces.

Nigirisushi: Cut raw salmon, tuna and whitefish into cubes, cut king prawns lengthwise. Take approx. 2 tbsp sushi-rice and shape into a medium large ball, put some wasabi on top and cover with fish or king prawns.

Serve the sushi with soy sauce, wasabi and pickled ginger.

Riz japonais à sushi : 1 kg de riz ; 30 g de sel ; 60 g de sucre ; 120 ml de vinaigre de riz

Pour les différents types de sushi : nori (feuilles d'algue) ; wasabi (raifort japonais) ; 1 concombre ou 150 g de saumon cru ; surimi (pâte de chair de poisson) ; 1 avocat ; graines de sésame grillées ; thon (de qualité sushi) ; poisson blanc ; gambas cuites ; sauce de soja, wasabi et gingembre mariné comme dip

Cuire le riz 20 minutes, laisser refroidir, mélanger avec le sel, le sucre et le vinaigre de riz.

Makisushi : Etaler le riz sur une feuille de nori, environ 1/2 cm d'épaisseur, recouvrir d'un peu de wasabi et placer au milieu le concombre en lamelles ou le saumon. Rouler la feuille dans la natte de bambou, former un rectangle et couper en six morceaux.

Rouleau inside-out (maki californien) : Etaler régulièrement une poignée de riz sur une feuille de nori, retourner la feuille, y déposer un filet de wasabi et garnir de lamelles de surimi et d'avocat. Former à l'aide de la natte de bambou un rouleau homogène, passer un ou plusieurs côtés dans le sésame grillé et couper en six morceaux.

Nigirisushi : Couper en rectangles le saumon cru, le thon et le poisson blanc et couper dans le sens de la longueur les gambas cuites. Prendre environ 2 c. à soupe de riz dans la main et façonner un petit pain, mettre un peu de wasabi sur le dessus et garnir avec le poisson ou les gambas.

Le sushi est servi avec la sauce de soja, le wasabi et le gingembre mariné.

Arroz de sushi japonés: 1 kg de arroz; 30 g de sal; 60 g de azúcar; 120 ml de vinagre de arroz

Para las diferentes clases de sushi: nori (hojas de algas marinas); wasabi (rábano japonés); 1 pepino o 150 g de salmón crudo; surimi (carne de cangrejo de mar); 1 aguacate; granos de sésamo tostados; atún (calidad para sushi); mújol; gambas, cocidas; salsa de soja, wasabi y jengibre macerado como "dip"

Cocer el arroz 20 minutos, dejarlo enfriar y mezclarlo con sal, azúcar y vinagre de arroz.

Makisushi: Esparcir sobre una hoja de nori el arroz de sushi con un grosor de aprox. 1/2 cm, untar con algo de wasabi y poner en el centro el pepino a pedazos alargados o el salmón. Enrollar con la ayuda de una estera de bambúes y cortar en seis trozos.

Rollo "Inside-Out" (maki California): Esparcir un puñado de arroz de sushi de forma uniforme sobre la hoja de nori, dar la vuelta a la hoja, poner encima un trozo alargado de wasabi y cubrir con surimi y pedazos alargados de aguacate. Formar un rollo rectangular y uniforme con ayuda de una estera de bambúes, mojar uno o varios lados en el sésamo tostado y cortar en seis trozos.

Nigirisushi: Cortar el salmón crudo, el atún y el mújol a trozos cuadrados y cortar a lo largo las gambas cocidas. Tomar en la mano aprox. 2 cucharadas de arroz de sushi y formar un bloque algo más grande presionando ligeramente, poner algo de wasabi en la parte superior y cubrir con el pescado o bien con las gambas.

El sushi se sirve con salsa de soja, wasabi y jengibre macerado.

Riso per sushi giapponese: 1 kg di riso; 30 g di sale; 60 g di zucchero; 120 ml di aceto di riso

Per diversi tipi di sushi: nori (fogli di alga); wasabi (rafano giap.); 1 cetriolo da insalata oppure 150 g di salmone crudo; surimi (polpa di granchio); 1 avocado; semi di sesamo tostati; tonno (qualità sushi); pesce bianco; gamberetti lessati; salsa di soia, wasabi e zenzero in salamoia come salsa dip.

Fate cuocere il riso per 20 minuti, lasciatelo raffreddare e mescolatelo con sale, zucchero e aceto di riso.

Makisushi: Su un foglio Nori distribuite uno strato di riso per sushi spesso ca. 1/2 cm, spalmatevi un po' di wasabi e mettete al centro il cetriolo a striscioline o il salmone. Con l'aiuto di una stuoina di bambù formate un rotolo e tagliatelo in sei pezzi.

Rotolino inside out (California Maki): Distribuite uniformemente una manciata di riso per sushi su un foglio Nori, girate il foglio, sistematevi sopra una striscia di wasabi e farcite con surimi e striscioline di avocado. Con l'aiuto di una stuoina di bambù formate un parallelepipedo rettangolo, intingete uno o più lati nel sesamo tostato e tagliate in sei pezzi.

Nigirisushi: Tagliate il salmone crudo, il tonno e il pesce bianco in pezzi rettangolari e aprite i gamberetti lessati tagliandoli nel senso della lunghezza. Prendete in mano ca. 2 cucchiai di riso per sushi e, con una leggera pressione, formate un blocco un po' consistente, sistemate sulla parte superiore un po' di wasabi e farcite con il pesce o i gamberetti.

Il sushi viene servito con salsa di soia, wasabi e zenzero in salamoia.

Restaurant Tantris

Design: Stefan Braunfels, Maureen Schäffner | Chef: Hans Haas

Johann-Fichte-Straße 7 | 80805 München | Schwabing
Phone: +49 89 3 61 95 90
www.tantris.de | info@tantris.de
Subway: Dietlindenstraße
Opening hours: Tue–Sat 12 noon to 3 pm, 6:30 pm to 1 am
Average price: € 100
Cuisine: Modern french
Special features: Reservation essential, Michelin and Gault Millau prized

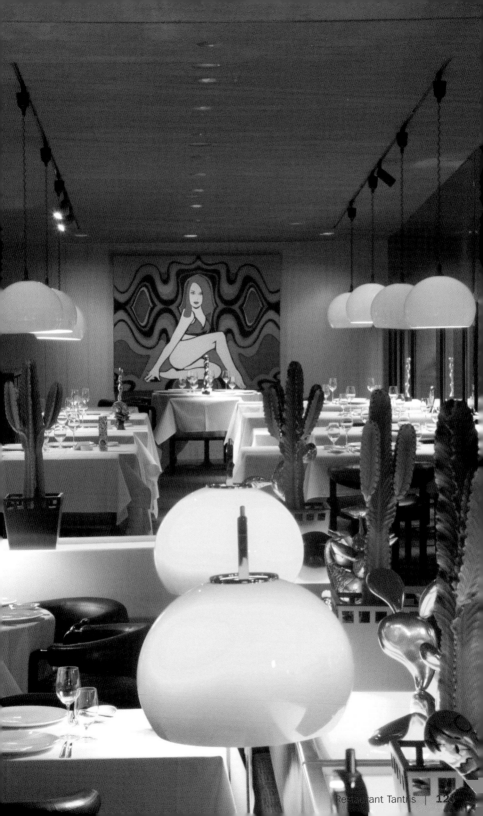

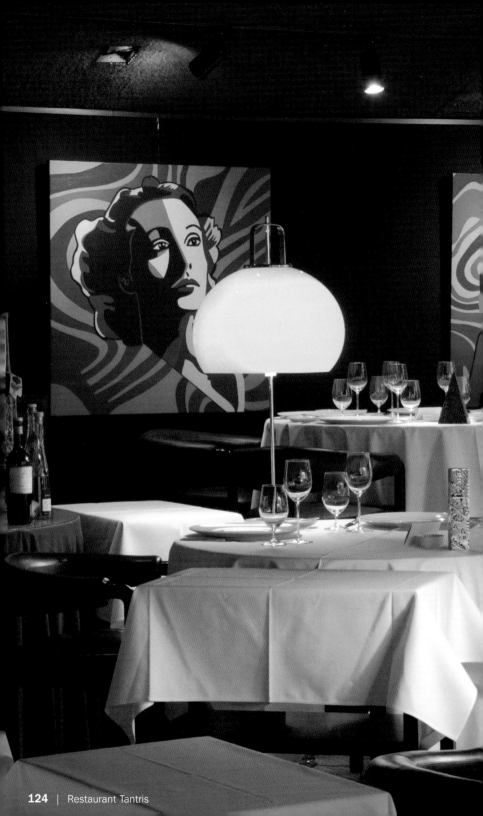

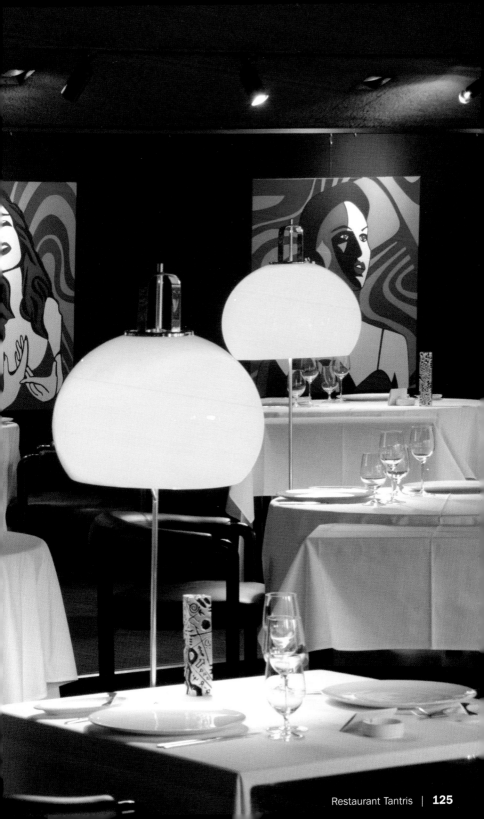

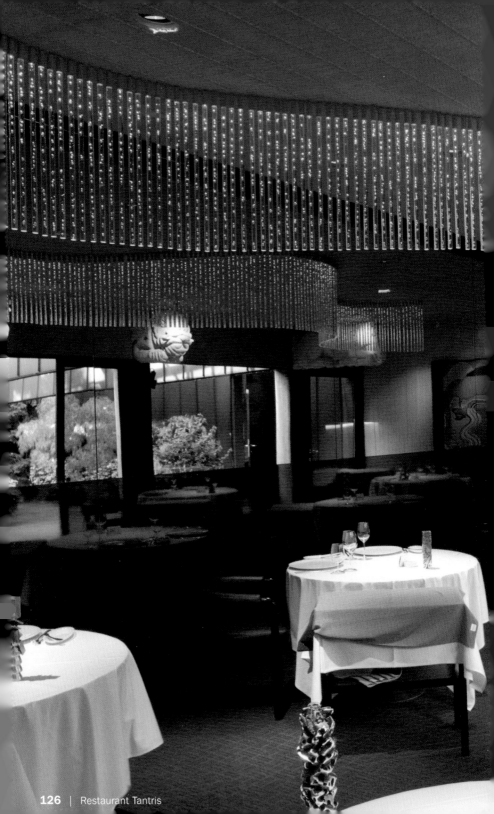

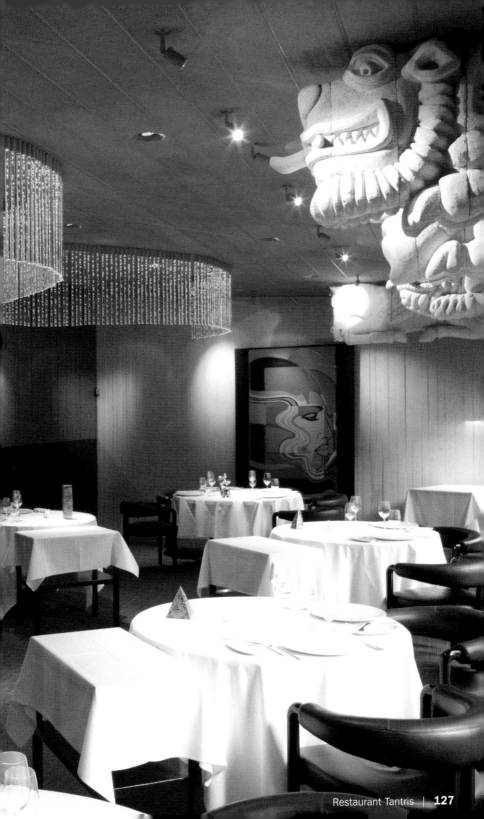

Sautierte Gambas

mit Fenchel-Variationen

Sautéed Gambas with Fennel-Variation

Gambas sautées avec variation de fenouil

Gambas salteadas con variación de hinojo

Gamberoni saltati con variazione di finocchio

Mit geschmortem Fenchel: 3 Fenchel; 4 EL Zucker; 200 ml Noilly Prat; 300 ml Orangensaft; 200 ml Geflügelbrühe; 100 g Butter; 8 Stück Sternanis; Salz, Pfeffer

Mit mariniertem Fenchel: 2 Fenchel in Scheiben; Saft von 2 Limetten; 200 ml Brühe; 4 EL Olivenöl; Salz, Pfeffer, etwas Zucker

20 Gambas; 2 EL Öl; 2 EL Butter; Salz, Pfeffer, Zitronensaft; etwas Salat zur Dekoration

Den Zucker im Topf karamellisieren. Wenn er goldgelb ist, mit Noilly Prat, Orangensaft und Geflügelbrühe ablöschen. Butter, Sternanis und Fenchel dazugeben. Mit Salz und Pfeffer würzen, mit etwas Pergamentpapier abdecken und im Ofen bei 160 °C ca. 1 Stunde schmoren bis der Fenchel weich ist. Dann herausnehmen und etwas abkühlen lassen.

Den rohen Fenchel mit Limettensaft, Brühe und Olivenöl mischen, mit Salz, Pfeffer und Zucker abschmecken und ca. 1 Stunde marinieren. Den marinierten und geschmorten Fenchel auf einem Teller anrichten. Die Gambas mit Salz, Pfeffer und etwas Zitrone würzen und in einer heißen Pfanne mit etwas Öl und Butter kurz anbraten. Herausnehmen, auf dem Fenchel verteilen und mit Salat garnieren. Zum Schluss mit der Fenchelmarinade leicht nappieren.

With braised fennel: 3 fennel; 4 tbsp sugar; 200 ml Noilly Prat; 300 ml orange juice; 100 ml chicken stock; 3 1/2 oz butter; 8 pieces star anise; salt, pepper

With marinated fennel: 2 fennel, sliced; juice of 2 limes; 200 ml broth; 4 tbsp olive oil; salt, pepper, pinch sugar

20 gambas; 2 tbsp oil; 2 tbsp butter; salt, pepper, lemon juice; salad for decoration

Heat sugar in a pot until golden brown, then add Noilly Prat, orange juice and chicken stock. Add fennel, butter and star anise. Season with salt and pepper, cover with baking parchment and place in a 320 °F oven for 1 hour until fennel is tender. Then remove from liquid and let cool down.

Mix raw fennel with lemon juice, chicken stock, olive oil and season with salt, pepper and sugar. Marinate for 1 hour.
Place braised and marinated fennel on a plate. Season Gambas with salt, pepper and lemon juice and fry in hot oil-butter mixture very quickly. Remove from pan, arrange on fennel and decorate with salad. At last drizzle with fennel marinade.

Fenouil braisé : 3 fenouils ; 4 c. à soupe de sucre ; 200 ml de Noilly Prat ; 300 ml de jus d'orange ; 200 ml de bouillon de volaille ; 100 g de beurre ; 8 anis étoilés ; sel, poivre

Fenouil mariné : 2 fenouils en tranches ; jus de 2 limettes ; 200 ml de bouillon ; 4 c. à soupe d'huile d'olive ; sel, poivre, un peu de sucre

20 gambas ; 2 c. à soupe d'huile ; 2 c. à soupe de beurre ; sel, poivre, jus de citron ; un peu de salade pour la décoration

Caraméliser le sucre dans une casserole. Quand il est doré, mouiller avec le Noilly Prat, le jus d'orange et le bouillon de volaille. Ajouter le beurre, l'anis et les fenouils. Saler et poivrer, recouvrir avec un peu de papier sulfurisé et enfourner à 160 °C environ 1 heure jusqu'à ce que les fenouils soient cuits. Les sortir du four et laisser refroidir.

Mélanger les fenouils crus avec le jus de limette, le bouillon et l'huile d'olive, assaisonner avec le sel, le poivre et le sucre. Laisser mariner environ 1 heure.

Dresser les fenouils marinés et braisés sur une assiette. Assaisonner les gambas avec le sel, le poivre et un peu de citron. Les faire revenir brièvement dans une poêle avec un peu d'huile et de beurre. Les sortir de la poêle et les répartir sur les fenouils. Garnir avec la salade. Pour terminer, napper légèrement avec la marinade de fenouil.

Asado de hinojo: 3 hinojos; 4 cucharadas de azúcar; 200 ml de Noilly Prat; 300 ml de zumo de naranja; 200 ml de caldo de ave; 100 g de mantequilla; 8 trozos de anís estrellado; sal, pimienta

Marinada de hinojo: 2 hinojos a rodajas; el zumo de 2 limas; 200 ml de caldo; 4 cucharadas de aceite de oliva; sal, pimienta, algo de azúcar

20 Gambas; 2 cucharadas de aceite; 2 cucharadas de mantequilla; sal, pimienta, zumo de limón; algo de lechuga para la decoración

Caramelizar el azúcar en la olla. Cuando esté amarillo dorado rebajar con el Noilly Prat, el zumo de naranja y el caldo de ave. Añadir la mantequilla, el anís estrellado y el hinojo. Condimentar con sal y pimienta, tapar con algo de papel de pergamino y asar al horno a 160 °C aprox. 1 hora hasta que el hinojo esté blando. Entonces echarle sal y dejar enfriar algo.

Mezclar el hinojo crudo con el zumo de lima, el caldo y el aceite de oliva, sazonar con sal, pimienta y azúcar y marinar 1 hora aprox.

Colocar en un plato el hinojo marinado y asado. Condimentar las gambas con sal, pimienta y algo de limón y freír brevemente en una sartén caliente con algo de aceite y mantequilla. Sacar, esparcir por el hinojo y adornar con lechuga. Al final, rociar ligeramente con la marinada de hinojo.

Con finocchio stufato: 3 finocchi; 4 cucchiai di zucchero; 200 ml di Noilly Prat; 300 ml di succo d'arancia; 200 ml di brodo di pollo; 100 g di burro; 8 pezzi di anice stellato; sale, pepe

Con finocchio marinato: 2 finocchi a fette; succo di 2 limette; 200 ml di brodo; 4 cucchiai di olio d'oliva; sale, pepe, un po' di zucchero

20 gamberoni; 2 cucchiai di olio; 2 cucchiai di burro; sale, pepe, succo di limone; un po' d'insalata per decorare

In un tegame caramellate lo zucchero. Non appena sarà dorato, versatevi il Noilly Prat, il succo d'arancia e il brodo di pollo. Aggiungete il burro, l'anice stellato e il finocchio. Salate e pepate, coprite con un po' di carta pergamenata e fate stufare in forno per ca. 1 ora a 160 °C finché il finocchio sarà tenero. Togliete quindi il finocchio dal forno e lasciatelo raffreddare.

Mescolate il finocchio crudo con il succo di limetta, il brodo e l'olio d'oliva, correggete con sale, pepe e zucchero e fate marinare per ca. 1 ora. Mettete il finocchio marinato e stufato su un piatto. Condite i gamberoni con sale, pepe e un po' di limone e fateli rosolare per qualche istante in una padella molto calda con un po' di burro e di olio. Toglieteli dalla padella, distribuiteli sul finocchio e guarnite con dell'insalata. Per finire, versatevi sopra un po' di marinata di finocchio.

YUM thai kitchen & bar

Design: Peter Bleyle | Chef: Sumitr Jomsri

Utzschneiderstraße 6 | 80469 München | Ludwigsvorstadt-Isarvorstadt
Phone: +49 89 23 23 06 60
www.yum-thai.de
Subway: Marienplatz
Opening hours: Every day 6 pm to 1am
Average price: € 12–16
Cuisine: Authenthic Thai food
Special features: Reservation recommended

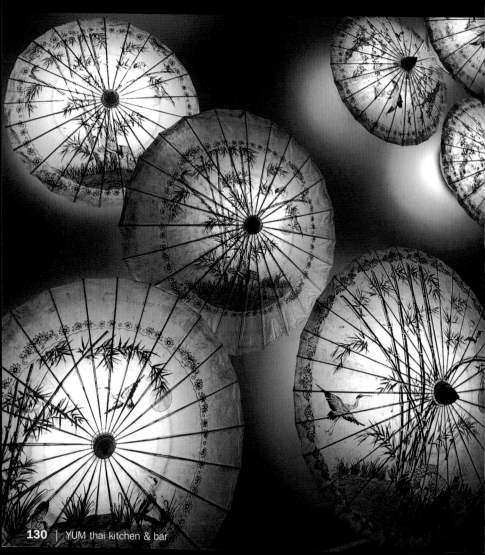

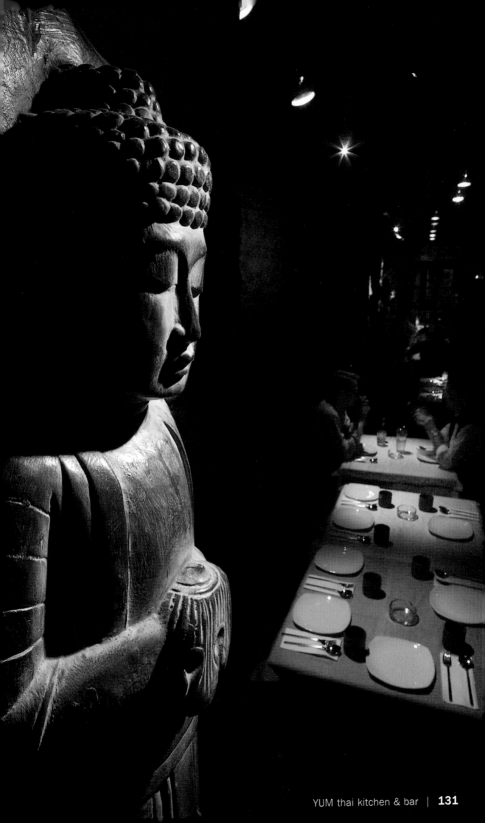

YUM thai kitchen & bar | **131**

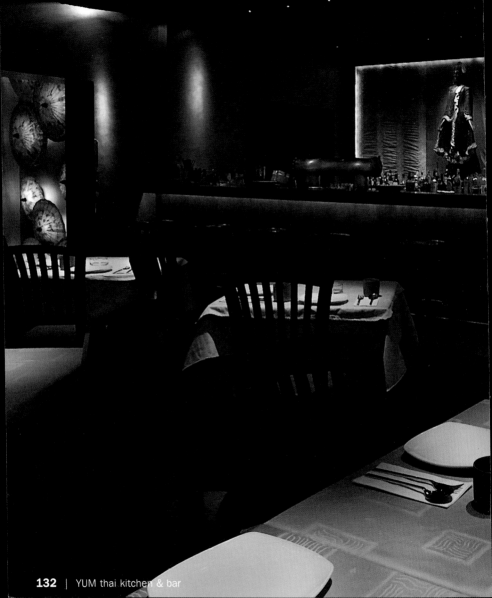

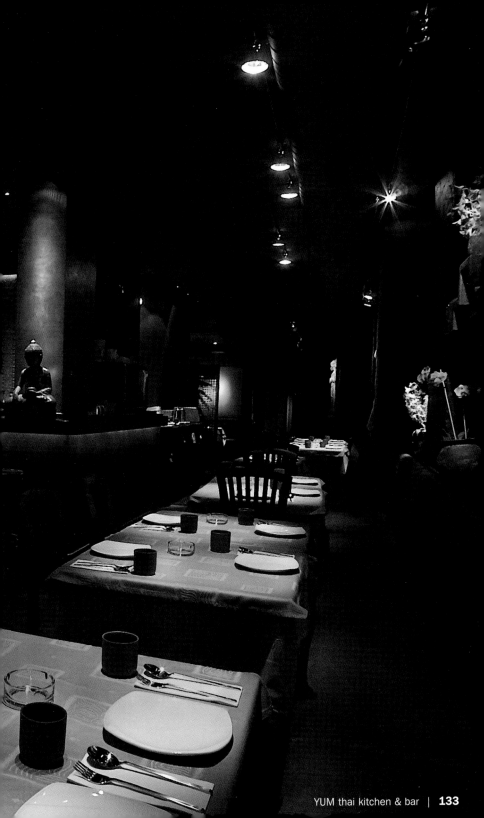

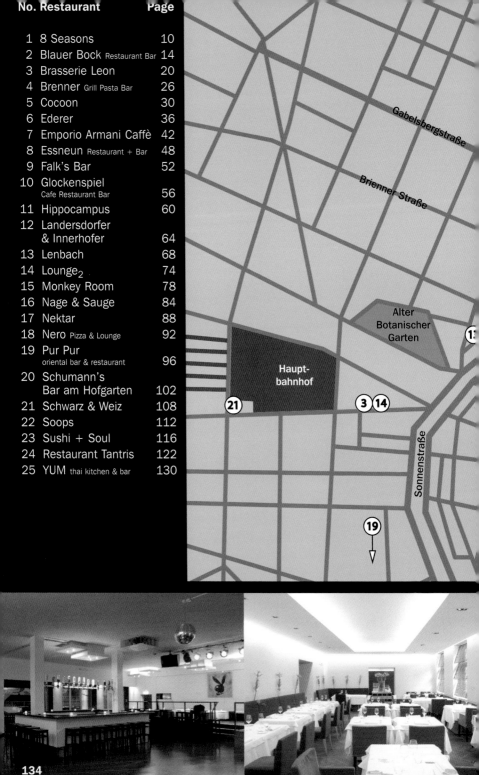

Gabelsbergstraße

Brienner Straße

Alter
Botanischer
Garten

Haupt-
bahnhof

Sonnenstraße

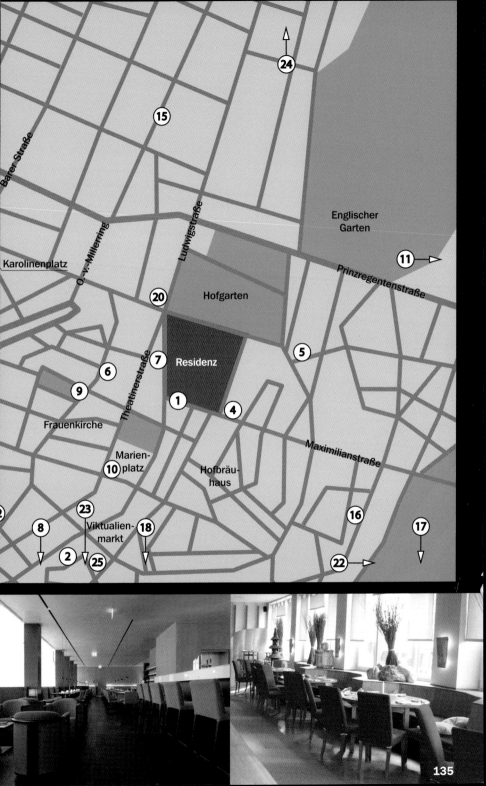

Cool Restaurants

Size: 14 x 21.5 cm / 5 ½ x 8 ½ in.
136 pp
Flexicover
c. 130 color photographs
Text in English, German, French,
Spanish and (*) Italian

Other titles in the same series:

Amsterdam (*)
ISBN 3-8238-4588-8

Barcelona (*)
ISBN 3-8238-4586-1

Berlin (*)
ISBN 3-8238-4585-3

Chicago (*)
ISBN 3-8327-9018-7

Côte d' Azur (*)
ISBN 3-8327-9040-3

Hamburg (*)
ISBN 3-8238-4599-3

London
ISBN 3-8238-4568-3

Los Angeles (*)
ISBN 3-8238-4589-6

Madrid (*)
ISBN 3-8327-9029-2

Milan (*)
ISBN 3-8238-4587-X

New York
ISBN 3-8238-4571-3

Paris
ISBN 3-8238-4570-5

Rome (*)
ISBN 3-8327-9028-4

Shanghai (*)
ISBN 3-8327-9050-0

Sydney (*)
ISBN 3-8327-9027-6

Tokyo (*)
ISBN 3-8238-4590-X

Vienna (*)
ISBN 3-8327-9020-9

To be published in the
same series:

Brussels Miami
Cape Town Moscow
Geneva Stockholm
Hong Kong Zurich

teNeues